Super Realism

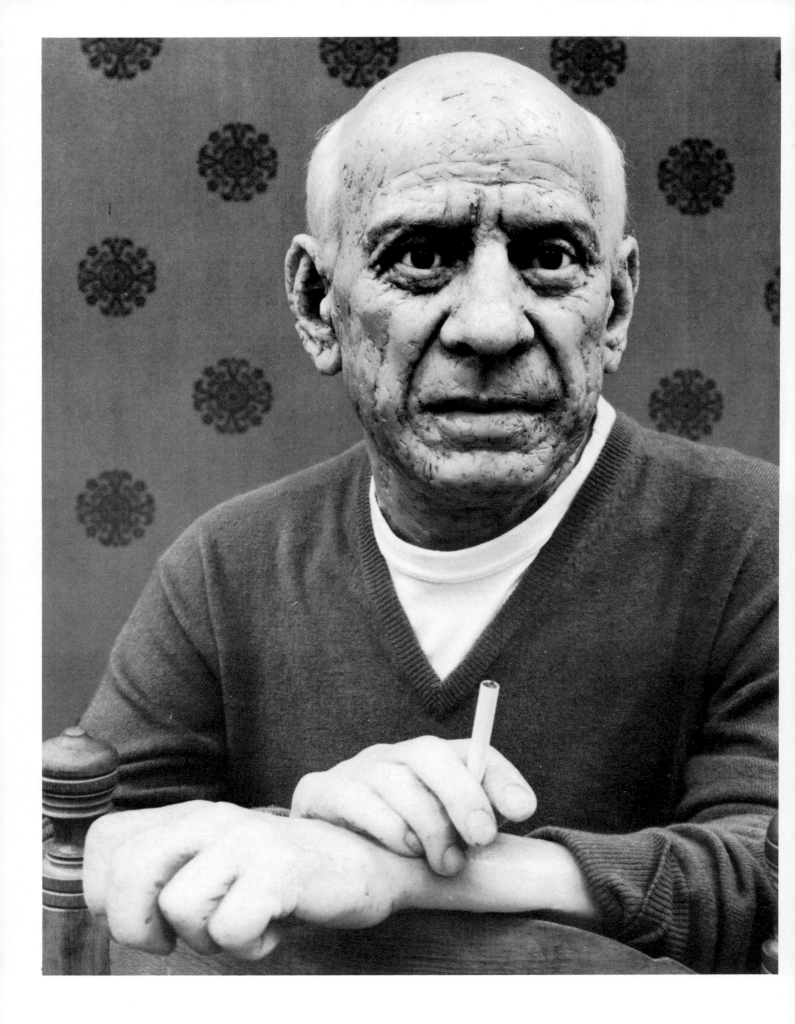

Super Realism

Edward Lucie-Smith

Phaidon · Oxford

Phaidon Press Limited, Littlegate House,
St Ebbe's Street, Oxford

First published 1979
Published in the United States of America
by E. P. Dutton, New York
© 1979 Phaidon Press Limited
All rights reserved

ISBN 0 7148 1971 9
Library of Congress Catalog Card Number: 78-73431

Printed in Great Britain by Waterlow (Dunstable) Ltd

1 (frontispiece). Jean Fraser: *Picasso*, detail. Mixed
media, lifesize. London, Madame Tussauds Ltd.

List of Plates

Select Bibliography

Art in America, special number, November/December 1972

Artscanada, 'Modes of Representational Art', special number, December 1976/January 1977

Gregory Battcock, ed., *Super Realism*, New York, 1975

Berlin: A Critical View—Ugly Realism, catalogue of an exhibition at the Institute of Contemporary Arts, London, November 1978/January 1979

Contemporary Spanish Realists, catalogue of an exhibition held at Marlborough Fine Art (London) Ltd, September/October 1973

Illusion and Reality, catalogue of an exhibition presented by the Australian Gallery Directors' Council at various Australian venues—Canberra, Perth, Brisbane, Sydney, etc., 1977

Udo Kultermann, *New Realism*, New York, 1972

The Modern Spirit: American Painting 1908–1935, catalogue of an exhibition organized by the Arts Council of Great Britain, Edinburgh and London, 1977

New/Photorealism, catalogue of an exhibition held at the Wadsworth Atheneum, Hartford, Conn., 1974

Les Peintres de la Réalité en France au XVIIe siècle, catalogue of an exhibition held at the Musée de l'Orangerie, Paris, 1934

Realismus und Realität, catalogue of an exhibition held at the Darmstadt Kunsthalle, Darmstadt, 1975

Barbara Rose, *American Art since 1900*, London, 1967

22 Realists, catalogue of an exhibition held at the Whitney Museum, New York, 1970

John Wilmerding, *American Art*, London, 1976

The Zebra Group, catalogue of an exhibition held at Fischer Fine Art Ltd., April/May 1975, London, 1975

Super Realism

I

As will emerge from this essay, there is more than a little disagreement about what Super Realism really is. Critics have coined some fascinatingly contradictory definitions or descriptions, which yet seem to possess a secret coherence, an inner unity. Here are four examples of what I mean:

With their magnified close-up visions of the exquisite realities of both the natural and the man made, [Super Realist artists] are reminding us of the beautiful gifts we are negligently squandering.
Cindy Nemser

These New—er Newer—Realists depict a fallen world with a fallen technique. They offer a universe of phenomena from which all traces of the numinous have been drained.
H. R. Raymond

The central concern of the Photo Realist is not the displaced and alienated man, but the world itself—he seeks not to create an image of man, but to clarify an image of all that is not man.
Linda Chase

In Photo Realism, reality is made to look so over-poweringly real as to make it pure illusion: through the basically magical means of point-for-point precisionist rendering the actual is portrayed as being so real that it doesn't exist.
Gerrit Henry

Yet one thing is certain. Super Realism, in purely worldly terms, is the only innovative art style to have achieved a marked success in the late sixties and early seventies. From its first appearance on the New York art-scene it scored a triumph with collectors. With critics and institutions it was somewhat slower to make an impact. But even there it has now made the breakthrough. It has been the subject of a number of exhibitions—in the United States, England, France, Germany, Canada and Australia. At least two books have been devoted to it, and there have, in addition, been several special issues of well-established art magazines as well as numerous scattered articles. From these sources the quotations given above have been taken.

Despite the existence of such a mass of documentation, Super Realism remains elusive. Many painters and some sculptors in America, and now more recently in Europe, are labelled Super Realist, but they often seem to have little in common. This elusiveness and lack of identity is perhaps due, in part at least, to the inherent difficulties presented by the term realism, no matter what qualifying adjective is coupled with it. The problems connected with the word, especially when it is applied to the visual arts, are well displayed in Raymond Williams's book *Keywords: a vocabulary of culture and society*. Here the relevant entry tries to disentangle the various usages, both historical and actual, of 'real', 'reality' and

7

'realism'. In perhaps despairing terms, Williams finishes by speaking of 'the extraordinary current variation in uses of realism'. However, in the course of his discussion he does make one point which is extremely important in the present context—that realism in art is often accused of evading what is real in any deep sense by opting for mere static representation. Such representation, more particularly when it involves showing three-dimensional objects two-dimensionally on a flat surface, can, according to many well-qualified observers, never be anything more than a convention.

There are, as it happens, additional difficulties lying in wait for the critic who tries to discuss the Super Realist art of the present day. These are not so much semantic as historical, and they concern the relationship of this style (granted indeed that this is recognizable and definable) both to post-war American art and, in a broader context, to the general development of the modern movement as this has existed since the beginning of the present century. It can be seen from what follows that Super Realist painting and sculpture can be thought of both as a logical extension of what American modernism has achieved in the years after 1945, and as a deliberate negation of it. Critical uneasiness about art of this type has been based not only on philosophical uncertainty, nor on its astonishing material success, but on its apparent lack of all the qualities which experience of modern art has taught us to value most highly.

While it might seem more logical to examine Super Realism first in a broad context—the paintings and sculptures do, after all, suggest many comparisons with art produced long before 1900—the modernist issue is so crucial that it is in fact more useful to consider the new style first simply in relation to what immediately preceded it in the development of American art. Looked at in this deliberately myopic way, it appears as the latest in a complex progression of styles which stretches back to the birth of Abstract Expressionism. Super Realism's immediate predecessor was the Pop Art of the early and middle sixties, an attempt, half-celebratory and half-ironic, to create high art out of the values, attitudes and characteristic artefacts of mass culture and the consumer society. There is in fact no clear break between Pop Art and Super Realism—painters such as Malcolm Morley and Mel Ramos can be categorized as pertaining to both. Some of the typical subject-matter of American Super Realist painting—advertising signs, shopfronts, automobiles, pictures from travel brochures—is extremely closely linked with the Pop repertoire. More than this, American Super Realism often seems to share with Pop a kind of nihilistic irony. A typical idea held in common by Pop artists and Super Realist ones is that of parodying well-known masterpieces—Roy Lichtenstein translates Braque and Picasso into the graphic idiom of the comic strip; Mel Ramos transposes Manet's *Olympia* into the equivalent of a *Playboy* centrefold; John Clem Clarke demystifies Rubens or Greuze. These are gestures modelled on those made by the pre-war Dada movement, and in particular they can be referred back to Duchamp's version of the *Mona Lisa—L.H.O.O.Q.*

What one finds in American Super Realism is both the uneasy consciousness of the contemporary urban environment, which simultaneously attracts the artist and arouses his disgust, and the equally uneasy recognition of art's minority status, however much it may truckle to the mob.

2. Malcolm Morley (b.1931): *On Deck*. 1966. Magnacolour and liquitex on canvas, 212.8 × 161.9 cm. (83¾ × 63¾ in.) New York, Nancy Hoffman Gallery

8

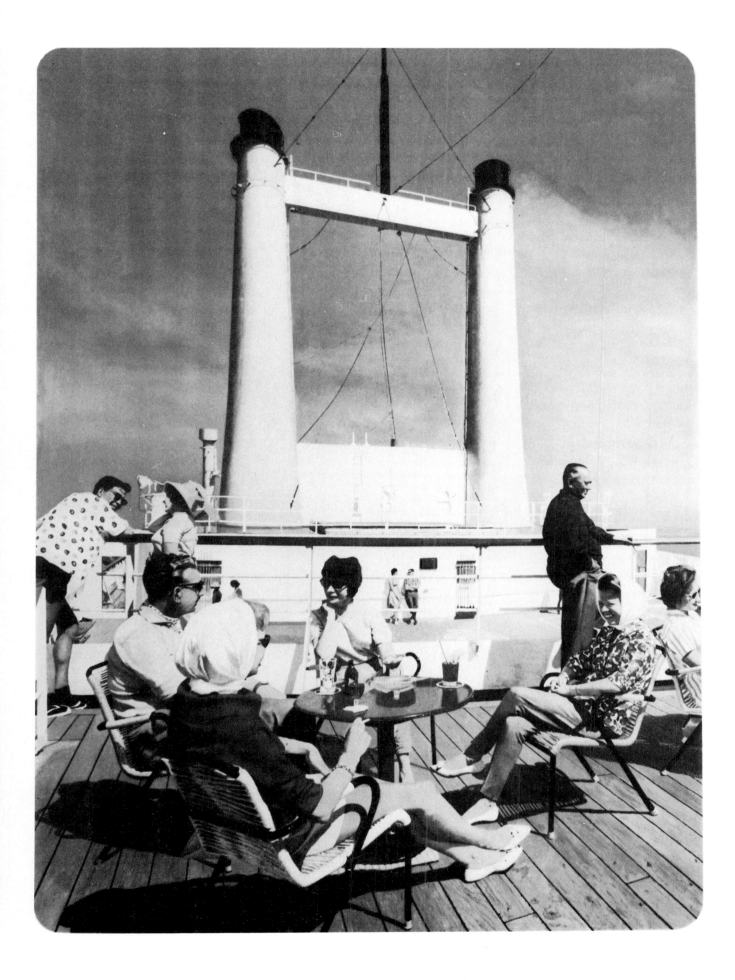

There is another way in which Super Realism can be seen as being related to Pop. If one looks at the way in which the New York art-scene was developing in the mid-sixties, the new style can also be interpreted as the response made by the Pop sensibility to the challenge of Conceptual Art. Essentially, Conceptual Art was an effort to push the formalist abstraction which was Pop's chief rival to a fresh extreme, by claiming that it was the pattern of thought which gave the work of art true aesthetic value, and that the physical embodiment was secondary. Thus the artist was free to abandon his traditional tools and materials, and could transmit his concept to the audience by the most minimal of means—for example, through a series of brief written statements pinned up on a gallery wall. Such statements were, according to conceptual theory, enough to 'stand in place of' the expected painting or sculpture.

At first glance Super Realism and Conceptual Art appear to be not only rivals, but opposites. On closer inspection it is possible to discover an important link between them in the nature of Super Realism's relationship to photography. This is so close that Photo Realism has sometimes (though I think erroneously) been used as an alternative and interchangeable label for the whole movement. Super Realist artists were not the first to rely heavily on the camera, and in many ways they used it in thoroughly traditional fashion—as a crutch, as an eye which could see more than they could themselves, as a means of achieving a more leisurely and intimate approach to their subject-matter, and as a challenge to be overcome. As one critic remarks: 'The act of painting slowly and laboriously what the camera can record quickly and effortlessly becomes a metaphor for the essentially meaningless act of existence.'

The ambition to outdo the photograph, both in detail and in intensity, has of course haunted many artists since photography was invented in the fourth decade of the nineteenth century. But Super Realism provided perhaps the first occasion when some artists turned this aspiration into something approaching a system. For critics like William C. Seitz this is indeed the most important thing about the movement as a whole: 'Unlike Courbet, Monet, Cézanne, Matisse, Hopper or even Stuart Davis, the Photo Realists do not make a personalised transformation of objects and phenomena as they exist extended in space and directly experienced. They utilize mechanical intermediary images already two-dimensional: slides, photographs, projections or printed material.'

But this seems to me an oversimplification. Super Realism's involvement with the camera is a matter of history, theory, and deliberate aesthetic choice. It has to do with what the picture looks like, as well as with how it comes to look the way it does. Pop Art, for example, had already made a speciality of imitating, not photographs, but the effects of crude colour printing. The evenly spaced dots and harsh outlines so typical of the work of Roy Lichtenstein derive directly from printing techniques used to produce comic strips, from which Lichtenstein also took much of his early iconography. Similarly, Andy Warhol made lavish use of photo-technology, silk-screening photographic images directly on to canvas. Malcolm Morley, trying to find as he said 'an iconography that was untarnished by art', hit on the idea of imitating, not the crudities of comic strips or the deliberate inexactitudes of Warhol's silk-screens, but the crisp gloss of good four-colour printing (Plate 2). Not merely the choice but the technique was interesting. In order to keep the impersonality of his original absolutely intact, Morley would cover his canvas so that only the small square he was working on remained visible, and would often paint the composition itself upside

10

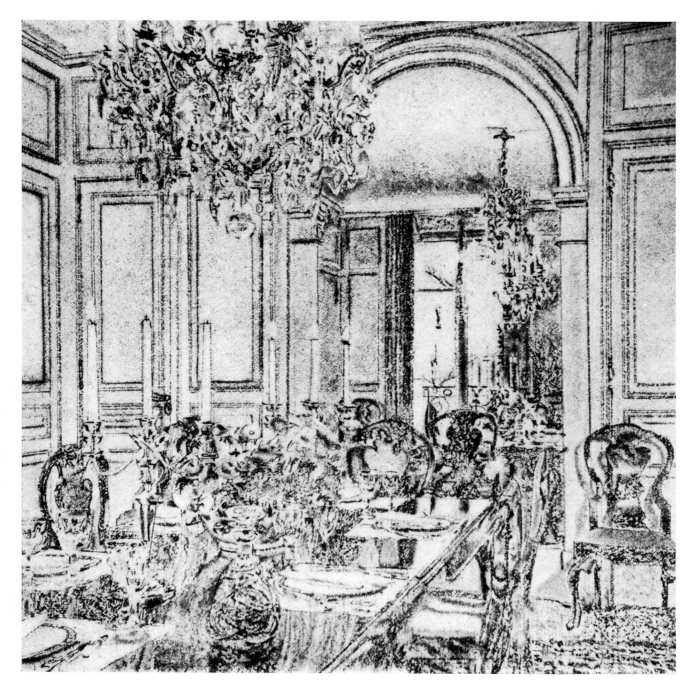

3. Richard Artschwager (b.1924): *Dining Room.* 1971.
Acrylic and liquitex on canvas, 111 × 110 cm. (43¾ × 43½ in.) New York, Leo Castelli Gallery

down. What he had done, and his nearness or otherwise to the chosen source, only revealed themselves when the whole painting was completed and uncovered. This rigid adherence to a wilfully chosen set of rules brought Morley's methods in the mid-sixties, if not his actual results, close to what Conceptual artists were doing at the same time, since he

too seemed to assert that the process of making art took primacy over the finished article.

From Morley's imitations of colour printing it was only a short step to imitating the photographs themselves. The idea of painting direct imitations of photographs had already occurred to another artist within the Pop orbit, Richard Artschwager (Plate 3), as early

11

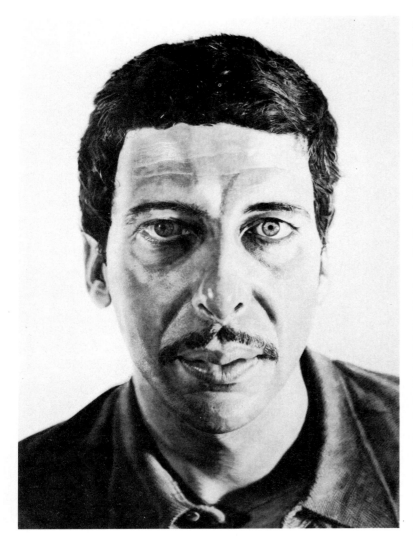

4. Chuck Close (b.1941): *Klaus*. 1976. Watercolour on paper, 203.2 × 147.3 cm. (80 × 58 in.) New York, Pace Gallery

as 1964. It was refined, and at the same time carried much further by Chuck Close, recognizably one of the chief figures in the American Super Realist school. Close's over-life-size heads (Plate 4)—self-portraits and portraits of friends—have indeed been regarded as among the most important products of the Super Realist movement in America. Their direct, centralized iconic presentation has made them seem like the successors, not merely of Warhol's large portraits of Marilyn Monroe and of Jaqueline Kennedy, but of the iconic abstracts painted by Mark Rothko.

In this particular context, what matters is the process through which they are created. Close, as he has said in an interview in the magazine *Artforum*, is concerned, not with how the eye sees, but with how the camera sees. His heads are, in fact, well chosen to demonstrate the difference. In the first place, the camera has monocular vision while our own vision is binocular. It is this monocular way of seeing which produces many of the aberrations we notice when we look at photographs, though these vary in turn with the actual choice of lens. Used for portraiture, wide-angle lenses produce distortions which are especially recognizable—in a full-face view, for example, the nose may seem unduly exaggerated in size and projection. In addition, when such a lens is used to make a close-up portrait at a wide aperture, the problem of focus becomes crucial. The zone in which focus is sharp may in these circumstances be only a few inches in depth—that is, less than the total depth of the head itself, or even of the mask. Thus, if the tip of the nose is in focus, the eyes will already be starting to blur. If, on the other hand, the eyes are crisply delineated on the negative, anything in front of them will be less so. Close knows that the human eye operates more flexibly than the camera, but he does nothing to compensate for these distortions. Instead, he chooses to

emphasize them so as to make the spectator aware of the exact nature of his source material —that is, what he is actually doing is painting an exact imitation of a photograph, rather than painting a portrait of a particular person. The use of what has been called 'intermediary material' has, among American artists in particular, been an important factor in the evolution of Super Realist style.

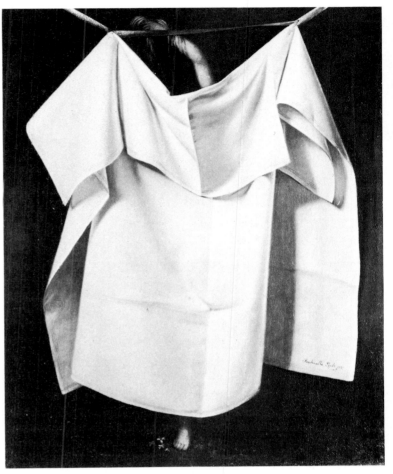

5. Raphaelle Peale (1774–1825): *After the Bath*. 1823. Oil on canvas, 73.7 × 61 cm. (29 × 24 in.) Kansas City, Atkins Museum of Fine Art

II

This may seem to contradict the fact that many people, artists as well as critics, have claimed that Super Realism is essentially styleless. The paradox is that its supposed neutrality in the face of the object immediately becomes an identifiable mannerism; Super Realism *is* a style. While it is possible to regard the Super Realist way of seeing as something completely *sui generis*—one adjective used for it is 'anti-hierarchical' because of the all-over vision of the camera and the multitude of centres of interest in each painting —it is also true to say that art of this kind is in many respects very close to one of the most basic traditions to be found in American art. This tradition has been growing and developing ever since the late eighteenth century. Among its earliest representatives are members of the Peale family of artists, including Raphaelle Peale (1774–1825) and James Peale (1749–1831). Both of these were painters of still-lifes which combine striking directness with lack of any overt emotional content. Raphaelle, in addition, painted *After the Bath* (Plate 5), a composition in which an illusionistic sheet, hanging from a line, almost entirely conceals the figure of a bather. This *tour de force* has something of Super Realism's inherent awkwardness, its preference for the facts themselves, rather than what imagination makes of them.

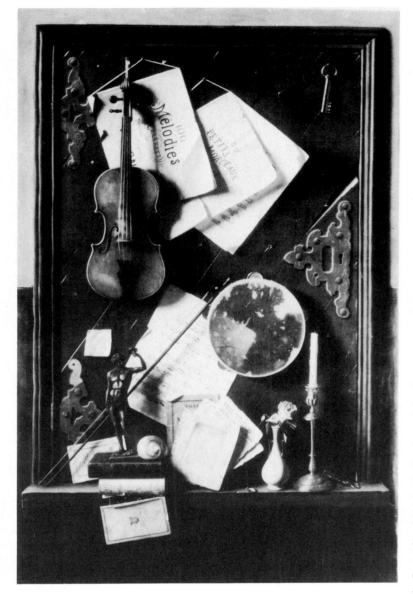

6. William Michael Harnett (1848–92): *The Old Cupboard Door*. 1889. Oil on canvas, 155 × 103 cm. (61 × 40½ in.) Sheffield, City Art Gallery

The tradition begun by the Peales was continued in the latter part of the nineteenth century by William Harnett (Plate 6) and his rivals and imitators. These specialized in *trompe-l'oeil* compositions which gain most of their effect from the peculiarity that most of the objects shown are depicted either as if they lie on the surface of the canvas, or as if they actually project from it into real space. Harnett's favourite device is to assemble letters, postcards and other souvenirs on a board with tapes stretched across it to hold them in place. This not only eliminates the problem of depth, but gives his paintings that quality of all-overness, with no one focus of interest being more important than any other, which reappears so powerfully in Super Realism.

A nearer and closer parallel to the Super Realist movement, and especially to much of the content of Super Realist painting, is provided by the American Precisionism of the 1920s. Precisionism practised a rationalization of forms in space which was meant to be the aesthetic equivalent of machine production and mechanical efficiency. Precisionist subject-matter was often the industrial landscape, and in this it was closely linked to the best photographic work of the time. Indeed, some Precisionists, such as Charles Sheeler, were equally distinguished both as painters and as photographers. Urban panoramas painted by accepted Super Realists, such as Noel Mahaffey and Gabriel Laderman (Plate 7), seem no more than a revival of the equivalent landscapes painted by Precisionists half a century earlier. But there are other parallels to be discovered as well. One of the things Precisionism took over from photography was an interest in close-up views, and this has been revived by a number of Super Realists—for example, in detailed paintings showing motorcycle engines and the interiors of automobiles (Plate 8).

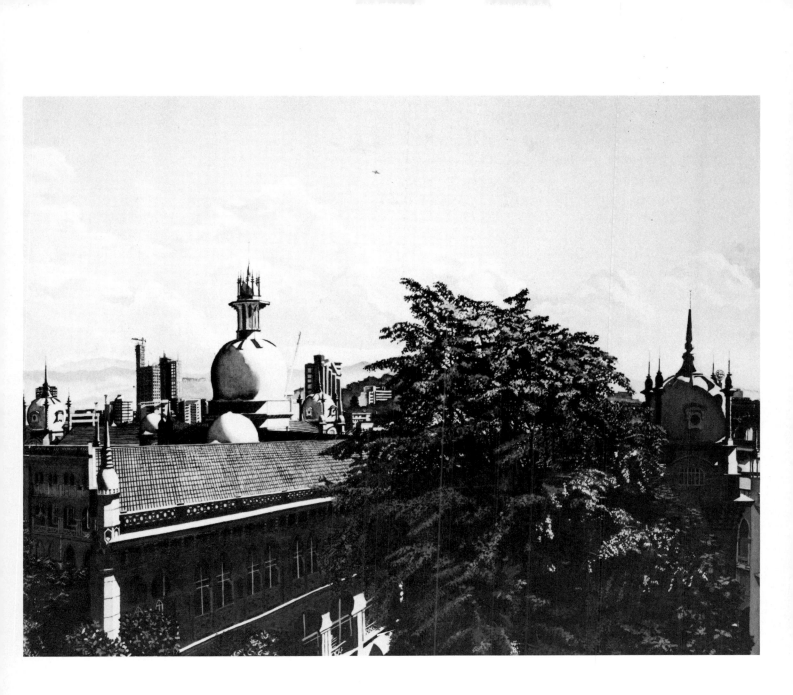

7. Gabriel Laderman (b.1929): *View of Kuala Lumpur*.
92.7 × 123.8 cm. (36½ × 48¾ in.) New York, Robert Schoelflopf Gallery

The truest link between the two schools, however, is to be found in their conscious Americanism—the search for subject-matter which would express in an emblematic way what it meant to be an American. It was this, as much as their obsession with the machine, which led the Precisionists to paint the modern industrial landscape—skyscrapers, bridges and factories. The American Super Realists usually tackle industry less directly, but it is a constant presence in their pictures, especially in those which feature the commercial clutter of the city and its periphery (Plate 9). Without industry, this clutter would not assume the forms it does.

Precisionism, despite this, might seem to be essentially optimistic, whereas Super Realism is pessimistic, a reflection of a ruined Eden. A link between the two schools is supplied by the work of Edward Hopper, the greatest artist of the American thirties. Hopper does not strive for the detailed perfection of finish which characterizes Super Realism on the one hand and Precisionism on the other. The attempt to create an illusion is not part of his relationship with observed reality. What he does share with these other painters, both senior and junior to himself, is a deep attachment not only to the idea of Americanism, but to the notion that Americanism is something essentially provincial. Like them, he searches for ideas and qualities which are rooted in particular places; which are cherished, not for their own obvious aesthetic merit but for an unmistakably native flavour. The mood of Hopper's paintings is often sombre, in key with the Depression. This sombreness is translated by the American Super Realists into a kind of harsh indifference as typical of Nixon's presidency as Hopper is of the Slump.

Yet, important as Hopper is as an ancestor, it is important to realize that there is another and rather different one. The art of Andrew Wyeth responds to a different kind of American chauvinist feeling. Wyeth conjures up a rural America which rejects, not only all foreign influence, but the impact and consequences of the Industrial Revolution itself. His precisely rendered vision of this segment of American life has made him hugely popular with his fellow countrymen. Super Realist art aims for the same kind of direct communication with a broad public. At the same time, it echoes things which already existed in Wyeth long before the Super Realist label was invented: not only his meticulous technique, but an assertion that what is known to exist is preferable to anything imagined. Super Realism makes an ironic transposition of Wyeth's skills and subject-matter—glittering technique is here, just as it is with him, an assertion that what is shown is worth contemplating for its own sake.

One can understand the things which join Wyeth to the Super Realists rather more clearly by looking northwards to Canada, which has produced some distinguished realists of its own. Canadians such as Ken Danby (Plate 10), Alex Colville (Plate 11) and Jack Chambers are like Wyeth because they celebrate nature and rural life; they are unlike him because they take the intrusions of modern technology in their stride. With them, the presence of the super-highway (nexus of much Super Realist imagery) is implied, even though the thing itself is not actually depicted.

8 (above). John Salt (b.1937): *Yellow Foam Interior.* 1970. Acrylic on canvas, 134 × 196 cm. (52¾ × 77¼ in.) Paris, Galerie des Quatre Mouvements

9 (below). John Baeder (b. 1938): *Clarksville Diner.* 1978. Oil on canvas, 76.2 × 121.9 cm. (30 × 48 in.) New York, O.K. Harris Gallery

16

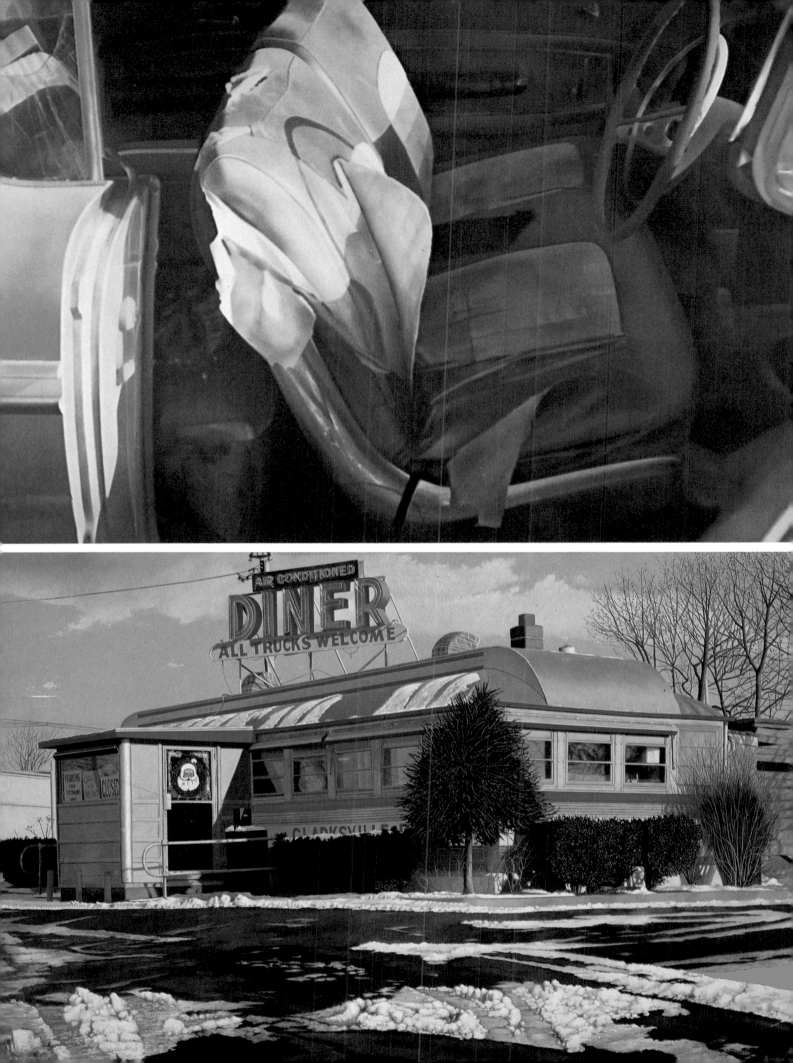

III

Super Realism, though of American origin, cannot be placed in a purely American context, and this for two reasons. One is that realism in art has a long and complex history, as relevant to this as it is to all the other kinds of realist painting. The other is that Super Realism, during the 1970s, ceased to be purely American. It is now possible to compile a long list of artists, all of them working in a more-or-less Super Realist mode, from a number of European countries. Among these are Britain, France, Spain, Portugal, West Germany, Sweden, Poland and Switzerland. That is, the return to realism must be recognized as an international impulse, though there are still some interesting differences between its manifestations on either side of the Atlantic.

From the historical point of view, the first school of realist painting that need concern us here is the one which took root in fifteenth-century Flanders, and which was headed by the brothers van Eyck. Jan van Eyck's *Arnolfini Wedding*, in the National Gallery, London, shows more than traces of ideas and intentions which reappear in late twentieth-century realist art, among them the urge to convince the spectator that what is shown has an actual objective existence, while still preserving a confusion as to whether this is to be discovered more essentially within the picture than outside it. Another, though less important, shared characteristic is the equal emphasis on all parts of the surface. Despite the sacred allusions, recondite and less recondite, made by many incidental details in the *Arnolfini Wedding*, the effect made by the painting is thoroughly secular. It is a reflection (as the mirror on the back wall tells us in a reinforcing metaphor) of the world as it actually is; and part of the pleasure we take in it comes from our recognition of this fact.

Seventeenth-century realism is far more complex. Here one can distinguish at least two different varieties. One is to be found in Italy and Spain, the other in northern Europe and particularly in Holland. Realist painting in France makes a kind of bridge between the two, combining things which are to be discovered in both. In Italy and Spain the impulse behind a new kind of realist painting seems to be essentially religious. It emerges as part of a desire to make painting an effective instrument of religious propaganda, a weapon in the hands of the Counter Reformation. It also expresses a feeling that the minutiae of daily life are permeated by the spirit of the divine, and that we can discover divinity itself by studying them. Yet the Baroque Naturalist artists of the first generation, and particularly Caravaggio, the most radical of them, have a paradoxical relationship to their immediate predecessors, the Mannerists. Caravaggio's early paintings show realism itself as the last weapon in the armoury of Mannerist artifice, the only means left of producing the feeling of astonishment (not to mention shock and disharmony) that Mannerism so consistently aimed at. It is irresistible, here, to make a comparison between Late Mannerism's relationship to Baroque Naturalism, and that between recent Minimal and Conceptual Art and Super Realism. In each case one sees a sudden overthrow, but an overthrow conducted according to the same rules that govern what is being attacked. A rarefied, elitist style gives way to a popular one, but those responsible for the defeat are themselves elitists.

The similarities between Dutch seventeenth-century painting and Super Realism are even more obvious. Both are essentially commercial products, made for a market which the artist recognizes and understands. In addition, both are confident that everyday things are a perfectly fit subject for art, and that on the

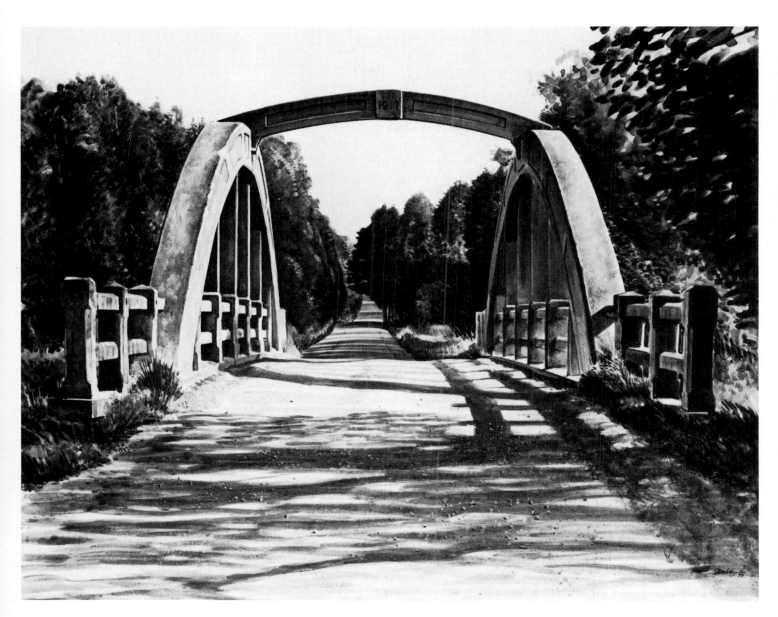

10. Ken Danby (b.1940): *Town Line Bridge*. 1977.
Watercolour, 53.3 × 68.6 cm. (21 × 27 in.) Toronto, Moos Gallery

whole the audience will be satisfied to see these reproduced without addition or commentary. It is of course true that we now discover, in one or two of the best Dutch painters (Vermeer, Saenredam and the young Pieter de Hoogh are cases in point), a secret impulse towards a more exact kind of visual order. But these are very much exceptions. The general run of Dutch painting is as thoroughly naturalist in its intentions as nearly everything we call Super Realism. Indeed, the most conspicuous difference is that Dutch genre scenes have an impulse towards narrative which Super Realism studiously avoids.

19

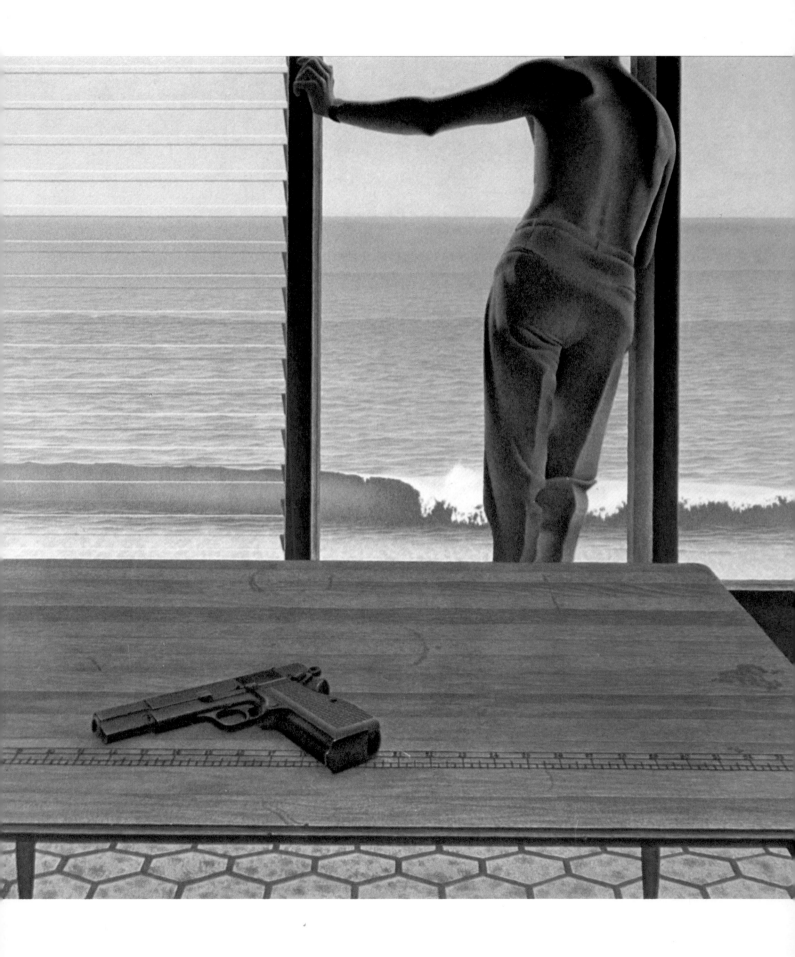

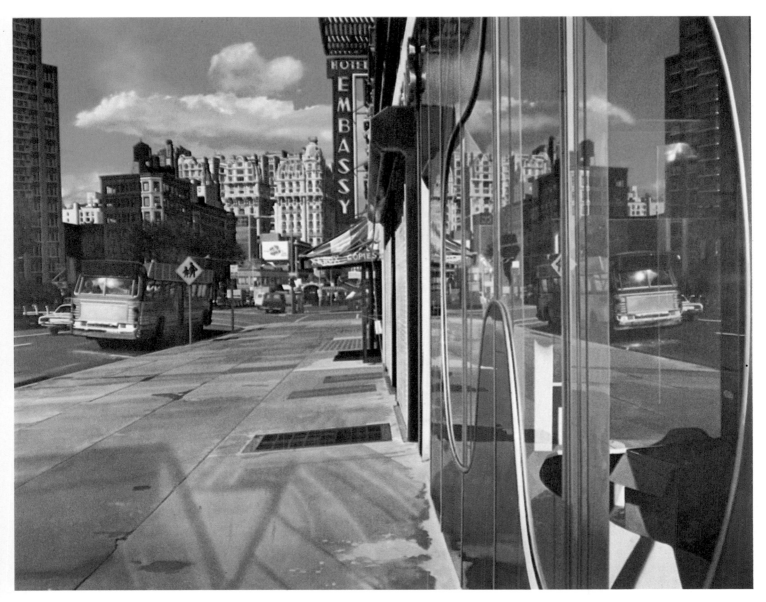

12. Richard Estes (b.1936): *Bus Reflection*. 1972.
Acrylic on canvas, 98 × 128 cm. (38⅝ × 50⅜ in.) New York, Collection Mr and Mrs Saul P. Steinberg

Secular naturalism makes its appearance in eighteenth-century Italy with the work of the painters of *vedute*, who not surprisingly worked chiefly for foreigners from the north. Pro-

11. Alex Colville (b.1920): *Pacific*. 1967. Acrylic on canvas, 53.5 × 53.5 cm. (21 × 21 in.) Canada, private collection

minent among the view-painters were Antonio Canaletto and his nephew Bellotto. It is to these two that Richard Estes (Plate 12), one of the most gifted American Super Realists, refers when asked to suggest a comparison for his own work. The choice is apt, as there are parallels of several kinds. For example, the painters of the Canaletto family made extensive use of the *camera obscura* when creating their paintings, and the distortions imposed by

21

this instrument are often visible in their work. Here one finds a close parallel with Super Realism's use of photography. In addition to this, Canaletto is essentially a painter who represents society very accurately without ever suggesting any close social involvement. His paintings usually contain numerous small figures busy with their daily activities. But the way in which these are presented is entirely emotionless. No statement about work, for instance, is either implied or intended by the famous *Stonemason's Yard*. Though Super Realist artists convey detachment in a different way, one is always conscious of their refusal to comment—something which makes them very different from leading nineteenth-century naturalists such as J. F. Millet.

Millet has now been restored to the pantheon of modernist forerunners. The same thing may soon happen to the nineteenth-century academic artists who were once regarded as the inveterate enemies of modernism. Nevertheless, one reason why Super Realism met with such a poor initial reception from established critics was because it reminded them immediately of a kind of art which had long been anathema. The impulse was, indeed, to dismiss the new art as a particularly undesirable kind of counter-revolution against everything which the visual arts had achieved since the days of Cézanne.

The issue turned, not only on the meticulous realism of Super Realist painting, but on its apparent attempt to rival photography. Throughout the nineteenth century, the battle of art versus photography had been fought out, often with considerable dishonesty. Photographers such as O. J. Rejlander used multiple negatives to make imitations of the Salon painting of the time. Artists of all kinds, from Delacroix onwards, made corresponding use of photographs as an aid to painting, though usually they were reluctant to admit it. However, the attraction of the photograph at first seemed irresistible. It more and more seemed to set a standard of excellence, interpreted as faithfulness to the model, which the painter must try to rival. This imperative was felt by artists as different from one another as the American realist Thomas Eakins and the Belgian Symbolist Fernand Khnopff.

For the academic Salon painter, the photograph tended to have another function as well. It distanced what he was depicting. Even when, as quite often, Salon artists attempted subject-matter with an urgent social message, the smoothness of their technique imposed a kind of emotional decorum which is not present in the work of other nineteenth-century realists, such as Daumier, Millet and Courbet. At the same time, the effort to rival photography—something strictly speaking different from the decision to use it as a source—led Salon painters to multiply the points of sharpest focus and visual interest in their paintings. This often resulted in a curious tug-of-war. Techniques imitated from the theatre, and already in use during the eighteenth century, impelled the artist to seek that combination of actions and gestures which would enable the narrative significance of the work to be absorbed at a glance. But the actual method of painting to some extent cancelled out this narrative impulse, giving the picture a glacial surface. This surface was imitated by the veristic Surrealists, such as Salvador Dali, in the twenties and thirties of the present century, but has been used in some ways more honestly by the contemporary Super Realists. The distancing effect can no longer be written off as mere avoidance. It is worth recalling in this context that Richard Estes once remarked that the real trouble with Pop Art was that it made too much comment. He seems to have meant that it would not allow reality to speak for itself.

Realism, after being challenged in all its aspects by the first generation of modernists,

re-emerged in Europe after the First World War, most conspicuously in Weimar Germany with the artists of the Neue Sachlichkeit. The return was caused in part by the impulse to draw back from the extremes of modernist experiment, which were associated with the catastrophe that had just taken place. But it had a more fundamental motive as well. Artists now wanted to try to get to grips with the great social issues of their time. Painters like Max Beckmann and Otto Dix were responsible for a bitter pictorial commentary on the woes of a decaying society. The effect of their work, particularly in the case of Dix, is often strikingly real, but the New Objectivity they boasted of was by no means emotionally neutral. Georg Grosz, another associate of the movement, once declared that his purpose was 'to convince the world it is ugly, sick and untruthful'.

Yet though one cannot find in the productions of the Neue Sachlichkeit an absolute mirror-image of reality, one can see in them an impulse towards anti-art which the painters of the group had inherited from their immediate predecessors the Dadaists. The theorists of the movement, such as the art historian Paul F. Schmitt, spoke of the importance of kitsch and the non-artistic; Dix himself was to say, in a spirit of hindsight, that his wish in the twenties had been to see things 'in close-up, and almost artlessly'. Obviously there is a direct link here with Super Realism, whose willed, rejecting neutrality has one of its roots in the Dadaist cult of the found object.

Certain European artists of the interwar period, working on the periphery of the major schools, did indeed produce work which comes very close to Super Realism. These cool, uncommitted realists appear chiefly in Germany, Scandinavia and Switzerland. They include the Swiss Niklaus Stöcklin (Plate 13) and the Swede Otte Sköld, both born just

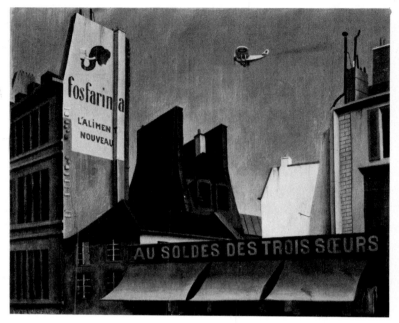

13. Niklaus Stöcklin (b.1896): *Au Soldes des Trois Soeurs*. 1930. Oil on canvas, 50 × 61 cm. (19⅝ × 24 in.) Basel, Kunstmuseum

23

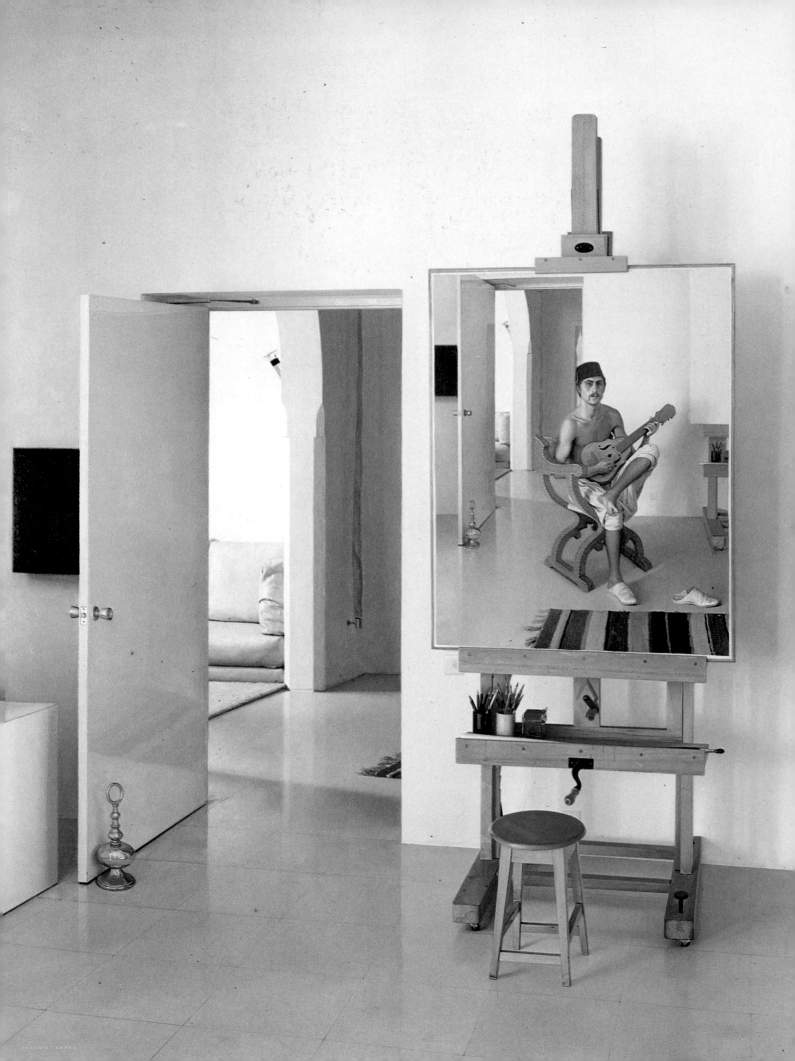

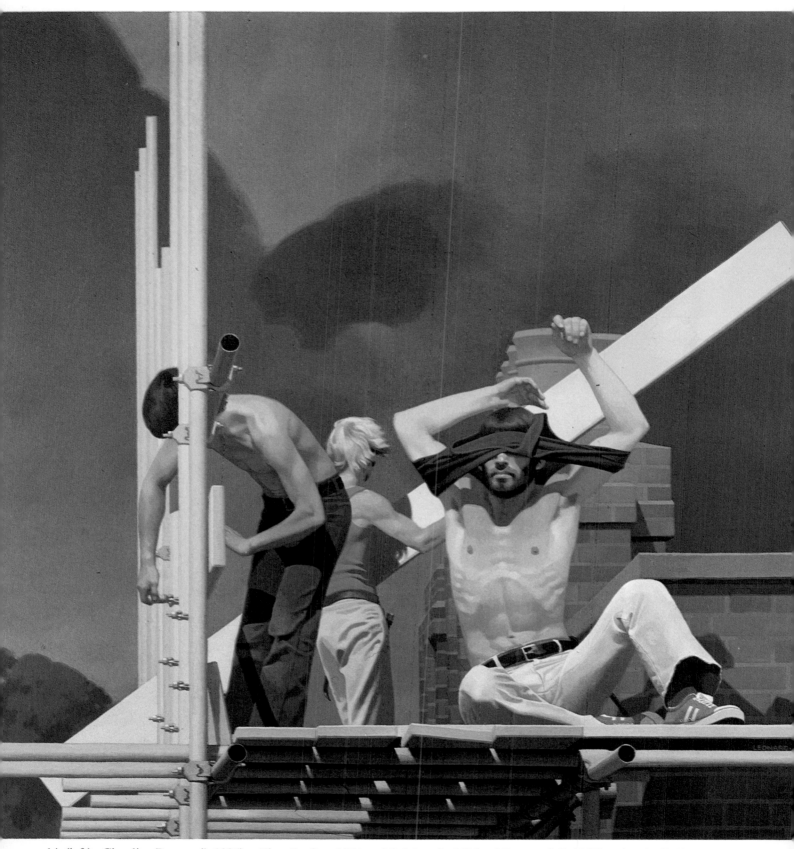

14 (left). Claudio Bravo (b.1936): *The Studio*. 1974.
Oil on canvas, 130 × 100 cm. (51 × 39½ in.) Paris,
Galerie Claude Bernard

15 (above). Michael Leonard (b.1933): *The Scaffolders*.
1978. Acrylic on canvas, 104 × 101.5 cm. (41 × 40 in.)
London, C S O Collection.

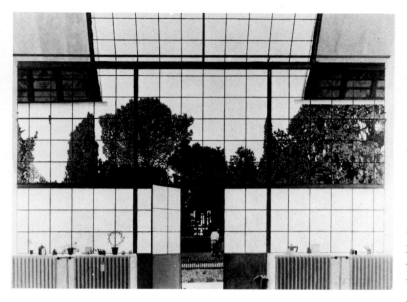

before the beginning of the twentieth century. Among the artists associated with the Neue Sachlichkeit in Germany were some who painted industrial landscapes and interiors very much in the manner of the American Precisionists.

Though Europe at first seemed to lag behind the United States in the creation of a Super Realist style, considerable numbers of objective realist painters began to make their mark on the European audience during the late sixties and the seventies. Partly they were inspired by the American example, though with a somewhat greater time-lag than usual; but partly they based themselves on their own native traditions. Only rarely, however, did European realist artists belong to any organized group.

The exception is West Germany, where a powerful realist art has developed in two stages. First came the Zebra Group, founded in 1965. The artists included in it were Asmus, Nagel, Störtenbecker (Plate 16) and Ullrich, and their aims were stated as follows: 'Our objective is to recreate an awareness of events by indicating quite clearly what our experience of this moment has been.' Their actual intellectual commitment was therefore closer to the artists of the Neue Sachlichkeit than it was to anything emerging in America at the same period. Correspondingly, little of their work is based on photographs. Some members of the group, however, and particularly Nikolaus Störtenbecker, have gradually come closer and closer to an approximation of Super Realist style.

17 (opposite above). Johannes Grützke (b.1937): *Three Naked Women*. 1973. Oil on canvas, 180 × 250 cm. (71 × 98½ in.) Hanover, Galerie Brusberg

18 (opposite below). Maina-Miriam Munsky (b.1943): *Colposcopy*. 1972. Oil on canvas, 150 × 180 cm. (61 × 71¼ in.) Courtesy the Institute of Contemporary Arts, London

16. Nikolaus Störtenbecker (b.1940): *Studio 9*. 1974. Oil and tempera on canvas, 180 × 225 cm. (70⅞ × 89¾ in.) London, Fischer Fine Art Ltd.

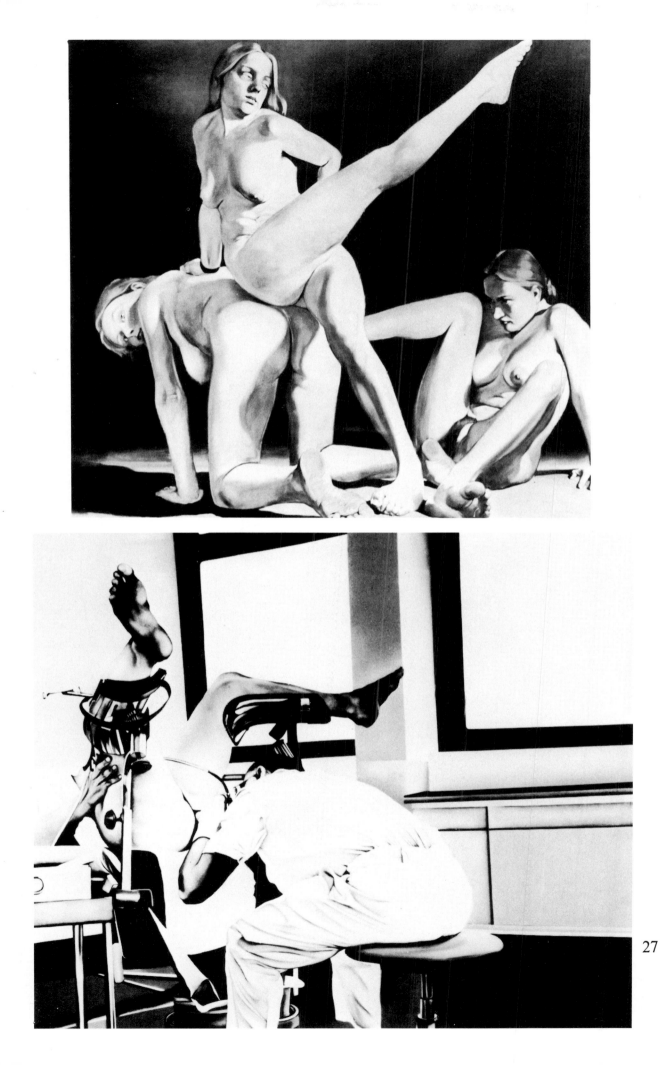

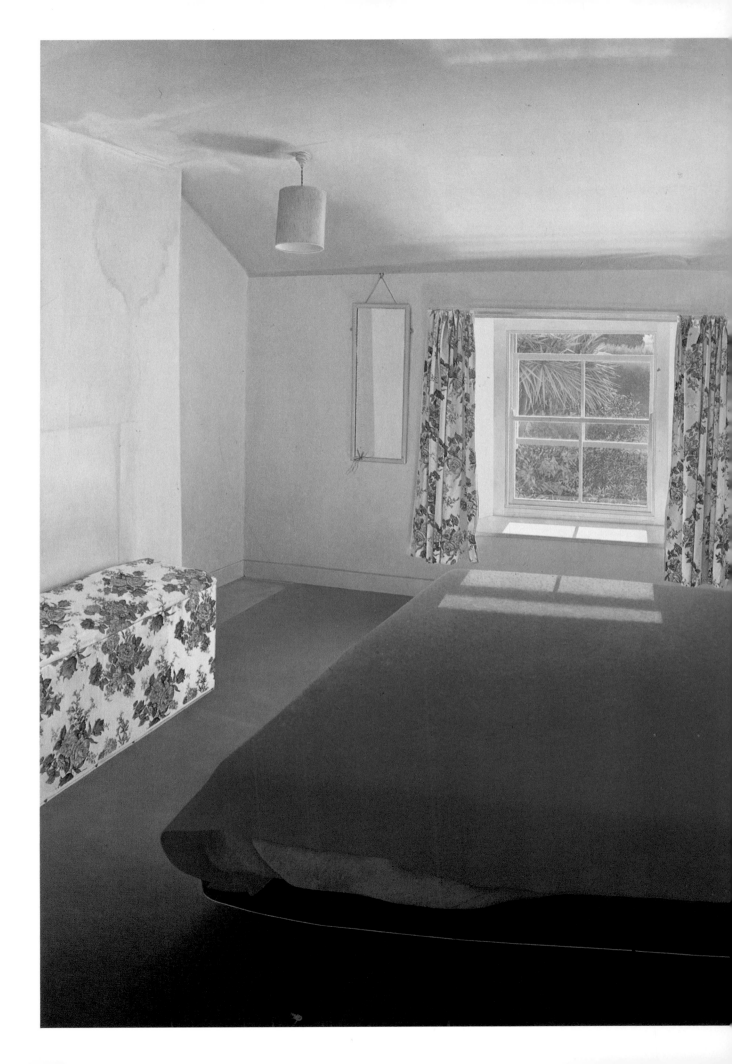

19. Diane Ibbotson (b.1946): *Begotten by the Sun*.
1975–6. Oil on canvas, 193 × 213.5 cm. (76 × 84 in.)
London, private collection

29

In the 1970s members of the Aspekt Group and other artists associated with West Berlin have been producing art in an idiom which has been labelled Ugly Realism or Critical Realism. This, too, owes something to Super Realism but even more to the realist art of the Weimar Republic. It is in general more aggressive and politicized than anything done by the Zebra Group painters. Intense realism, as in Maina-Miriam Munsky's pictures of operations (Plate 18), based on photographs taken by herself, is only one of a number of stylistic devices used by these Berlin artists to convey their feelings of revulsion against the way modern industrial society is developing. Two of the most typical and powerful of the new German realists are Johannes Grützke (Plate 17) and Matthias Koeppel, both of whom paint pictures which seem to lie almost exactly on the dividing line between true Super Realism and the Social Realism of a painter like Renato Guttuso.

Another European country where there is at least a loose grouping of realists is Spain, but this is a stylistic coherence which seems to have been imposed from outside, not by the artists themselves getting together. There have been a number of exhibitions of recent Spanish realist art, one in England, and several more in Germany. Paradoxically, the best-known member of the group, Claudio Bravo (Plate 14), is not Spanish either by birth or domicile. He is a Chilean who has taken up residence in Morocco. What links Bravo's work to that of the native-born Spaniards with whom he sometimes exhibits is a kind of glamour, also recognizable in more rhetorical form in the late painting of Dali (for example, *The Christ of St John of the Cross* now in Glasgow). Bravo endows banal objects—a wrapped parcel for instance—with magical clarity, as if the spectator were confronting them in a heightened state of consciousness. In fact, contemporary Spanish realist art pays tribute to traditions which stretch back as far as the seventeenth century, and which can be related to the rare still-lifes of Zurbarán, with their sacramental quality, and to those painted by Juan van der Hamen.

Elsewhere, the situation is a good deal more confused. In England, for example, there are two main groupings of realist artists, each associated with a different London gallery—Fischer Fine Art and the Nicholas Treadwell Gallery. Those affiliated to the Treadwell Gallery often tackle common themes, since the gallery itself favours theme exhibitions. All they seem to have in common, however, is a kind of English jokiness—a refusal to take either art or subject-matter entirely seriously. The artists who exhibit with Fischer Fine Art do not have even this small degree of coherence. Yet a closer look at the English scene does after all reveal subtle hints of national preferences. English classicism makes its appearance in some highly disciplined figure paintings by Michael Leonard—for example in *The Scaffolders* (Plate 15), where the figures are arranged as carefully as they would be in a Poussin. English domesticity gives a recognizable character to Diane Ibbotson's intense renderings of interiors (Plate 19), which hint, though on a much bigger scale, at some of the qualities one finds in Samuel Palmer's exquisite little romantic print, *A Chamber Idyll*.

IV

One significant aspect of the critical reaction to Super Realism, even where this was hostile, was its general tendency to categorize such painting in terms of subject-matter. At first sight, this seems peculiarly perverse, both in view of the fact that the Super Realist artist often seems more interested in a photograph of an object than he is in the object itself, and in view of the stress on neutrality of vision, whatever is depicted. Yet the instinctive

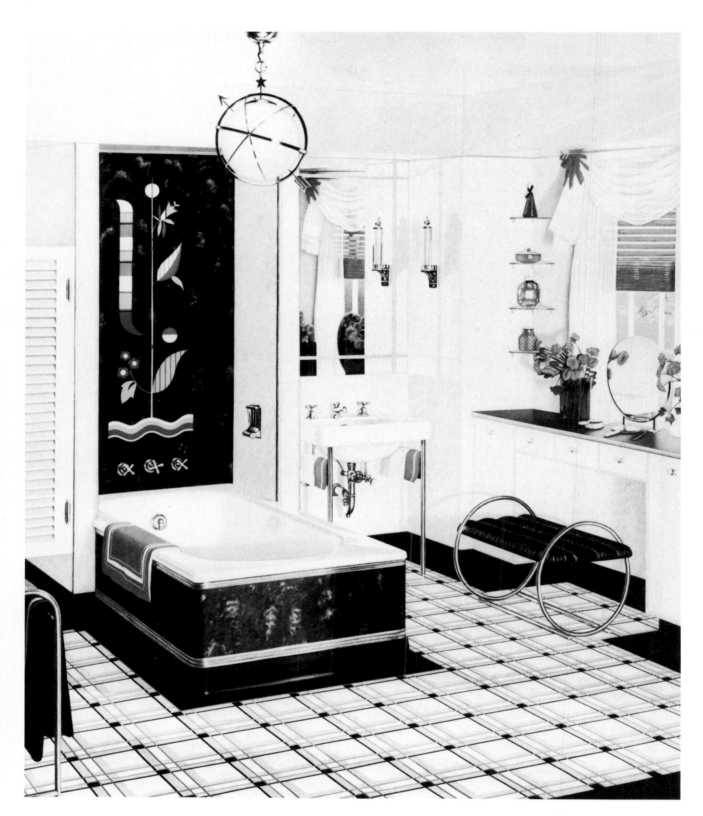

20. Douglas Bond (b.1937): *Bath Room*. 1972–3.
Acrylic on canvas, 193 × 162.6 cm. (76 × 64 in.) New York, O.K. Harris Gallery

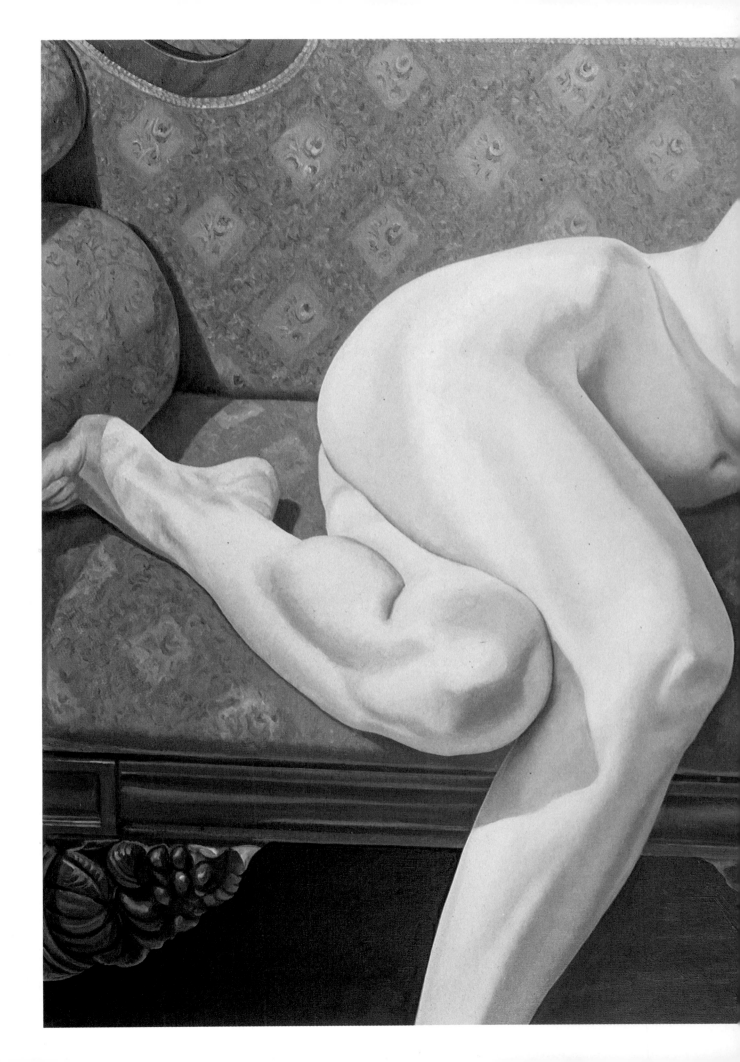

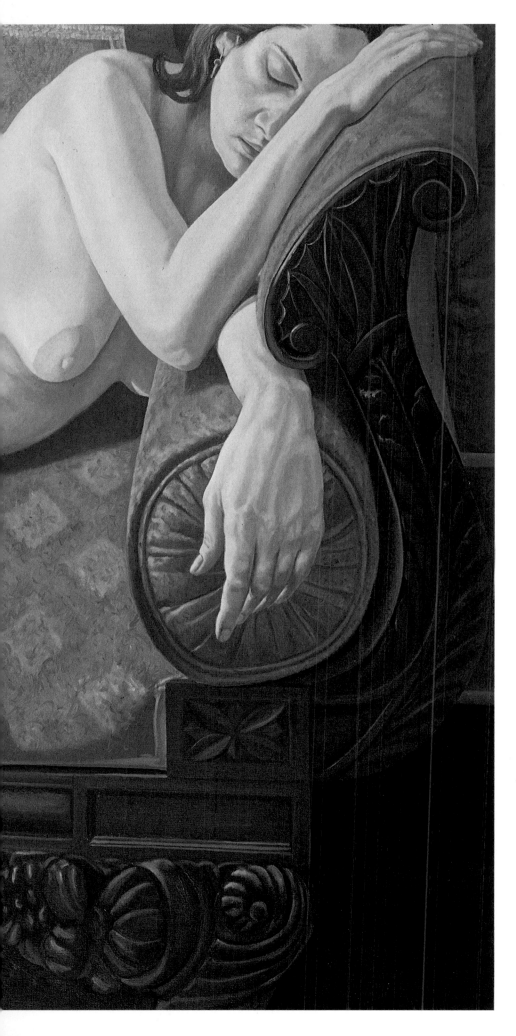

21. Philip Pearlstein (b.1924):
*Female Model Reclining on
Empire Sofa*. 1973. Oil on
canvas, 122 × 152 cm. (48 ×
60 in.) London, private
collection

33

reaction of the commentators has certainly something to justify it. Whatever its theoretical protestations, this art, like all art, does indeed comment on the environment which produces it, as much by what it fails to do as by what it actually does. The vaunted neutrality of the style very often (and some might say perversely) allows the subject-matter great weight.

If one analyses the subject-matter itself, not the method of presenting it, one still discovers a broad spectrum of attitudes. For example, both Malcolm Morley and Philip Pearlstein (Plate 21) have been regarded as Super Realist forerunners, yet each points in a completely different direction. What makes Pearlstein's figurative canvases of nudes different from the same subject-matter more classically presented is a curious emotional indifference, an unwillingness to be stirred. The human animal is shown as just that—an animal. Chuck Close, using photographs where Pearlstein refuses to have anything to do with them, and painting heads and not bodies, nevertheless subjects human beings to a coldly pitiless stare. The same is true of the portraits painted by Al Leslie. All three artists seem to assert that this is a world in which the numinous has no place.

Morley, too, is hostile to any kind of rhetoric. He deliberately deflates Pop subject-matter, and at the same time he attacks the audience more directly by moving up-market, turning a basilisk glare on middle-class pleasures and middle-class shibboleths—Valley Forge and the holiday brochure (Plate 2). Taking a hint from him, several Super Realist artists have made a speciality of painting the glossy middle-class interior—effective paintings of this sort, evidently based on illustrations in home-making magazines, have been painted by Douglas Bond and Jack Mendenhall (Plates 20 and 22). Using Morley as a stepping-off point in a rather different and more original way, Richard McClean has done a long series of paintings devoted to the contemporary cult of the American West, using material from specialist horse-show magazines (Plate 23). From Morley and McClean, Bond and Mendenhall, one can, if one elects to do so, build up an image of a society whose pleasures and values are almost entirely synthetic, and which is haunted by an aching sense of its own emptiness.

Morley and the other artists I have just mentioned, unlike Pearlstein and Close, are thoroughly ethnic. They take, not the whole human condition, but a specifically American aspect of it as their theme. It perhaps increases the sharpness of Morley's reactions to things American that he was born in Britain. Other Super Realist artists working in America seem to be equally moved by a sense of place, but with them it is more difficult to be certain whether they mean to celebrate or to condemn. Whereas American Pop Art was a phenomenon rooted in New York, from its beginnings American Super Realism has had a dual focus. California, and especially Los Angeles, played an important role in its development, and even where the Californian Super Realists treat much the same range of subject-matter as their rivals in the East, there is a perceptible difference in their approach.

The first artist to capture the special quality of the Los Angeles city-scape was in all probability an Englishman—David Hockney. But the spare lyricism of Hockney's evocations of Californian architecture and landscape has little to do with the kind of art I am talking about here. Robert Bechtle (Plate 24) and Ralph Goings (Plate 25) provide a convincingly detailed portrait of an environment, which, until the mid-sixties, had hardly captured the attention of artists of any sort. The automobile plays a predominant part in this environment, and it features often and prominently in the paintings. So too do the drive-in facilities which exist for the convenience of travellers. But we also see the Californians themselves.

caught in the poses one might find in snapshots taken for the family album. Indeed, it is snapshots of this sort which provide the raw material for many of the pictures. This, however, is less important than the fact that almost every picture draws attention to things which have never before formed the subject of art, partly because they are too new, and partly because no one previously thought them worth looking at. These things are dignified by the mere fact of being painted—we are forced to look at them in a different and more respectful way.

Paintings made by artists who have based themselves in New York are correspondingly influenced by the surrounding environment. Perhaps the most gifted New York artist, and indeed one of the most gifted painters thrown up by the whole Super Realist school, is Richard Estes (Plate 12). Estes takes up the traditional tasks of the view-painter, those undertaken for example by Canaletto and Jan van der Heyden, and subtly transforms them, simply by accepting what is there. His province is the New York street, or sometimes the New York subway. His materials are glass, shiny metal, plastic. These substances, however, are not the true subject of his paintings. He paints reflections and transparencies, criss-crossing, overlapping, contradicting one another and cancelling one another out. One of the ways in which he keeps his various ambiguities in order is through the use of lettering, sometimes seen the right way round but often reversed so that the spectator must strain to construe it. His pictures are based on photographs, but these are combined and edited in order to produce the image the artist wants. Underneath what is shown lies an interplay of abstract geometric forms. In fact, the longer one studies paintings by Estes the more one comes to realize that these are usually Synthetic Cubist compositions, with one plane floating in front of another in typically Cubist shallow space.

Another urban artist with a strong inclination towards the abstract ordering of forms is Robert Cottingham (Plates 26, 43). His sharply-angled views of fragments of New York fascias and shop-signs continue Pop Art's romance with decorative lettering, and at the same time give vent to a sharp verbal wit, so that the letters combine to spell out some message which those who put them up never originally intended—ODE perhaps, or even ART.

It is interesting to compare Estes's and Cottingham's handling of New York with what English artists do with similar material found in London. Both David Hepher (Plate 27) and Brendan Neiland (Plate 28) have recently been much concerned with reflections and patterns of windows as seen along the sides of towering council flats and office blocks. Neiland uses what he finds to create a shimmering surface, almost entirely abstract in its effect, but remains linked to Cottingham because of his preference for a raked viewpoint. Hepher, brought up in the sober Euston Road tradition, carefully particularizes his subject-matter, but does not make much play with the flash and glitter of a huge area of glass. Instead, he seems to mean his egg-crate apartment block to be taken as an emblem of the way people are forced to live in a modern collective society. The tiny variations in the pattern—curtains hung a different way, figures gossiping on a balcony—are made to look like defiant acts of resistance to the universal pressure to conform.

22 (overleaf). Jack Mendenhall (b. 1937): *Dressing Room with Chandelier*. 1978. Oil on canvas, 176.5 × 171.5 cm. (69½ × 67½ in.) New York, O.K. Harris Gallery

35

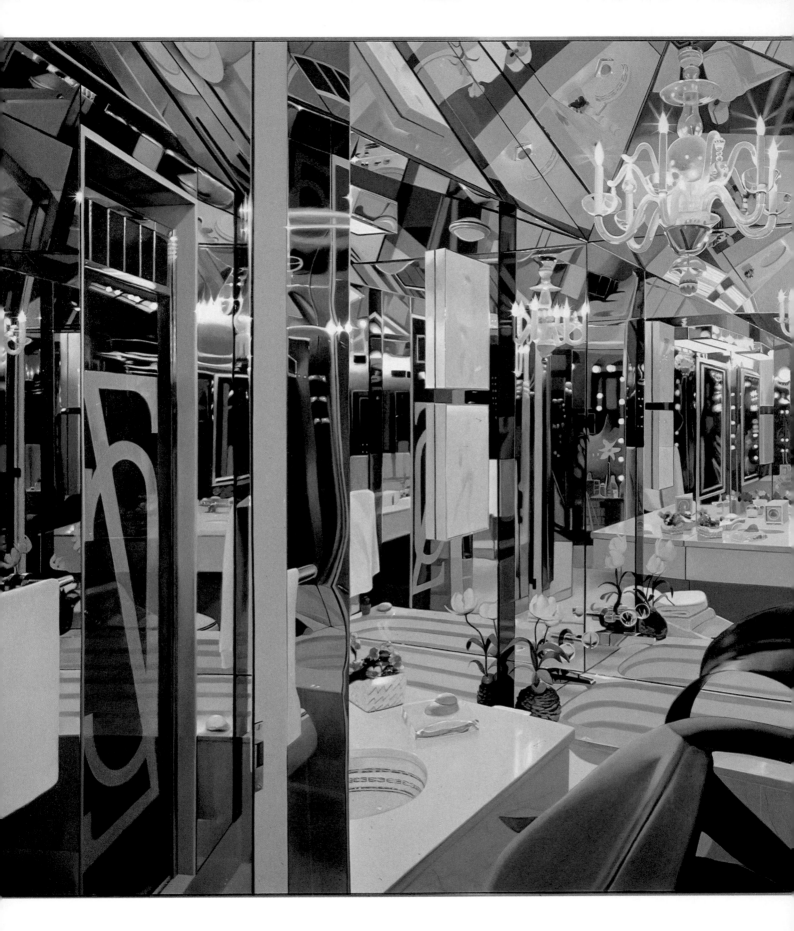

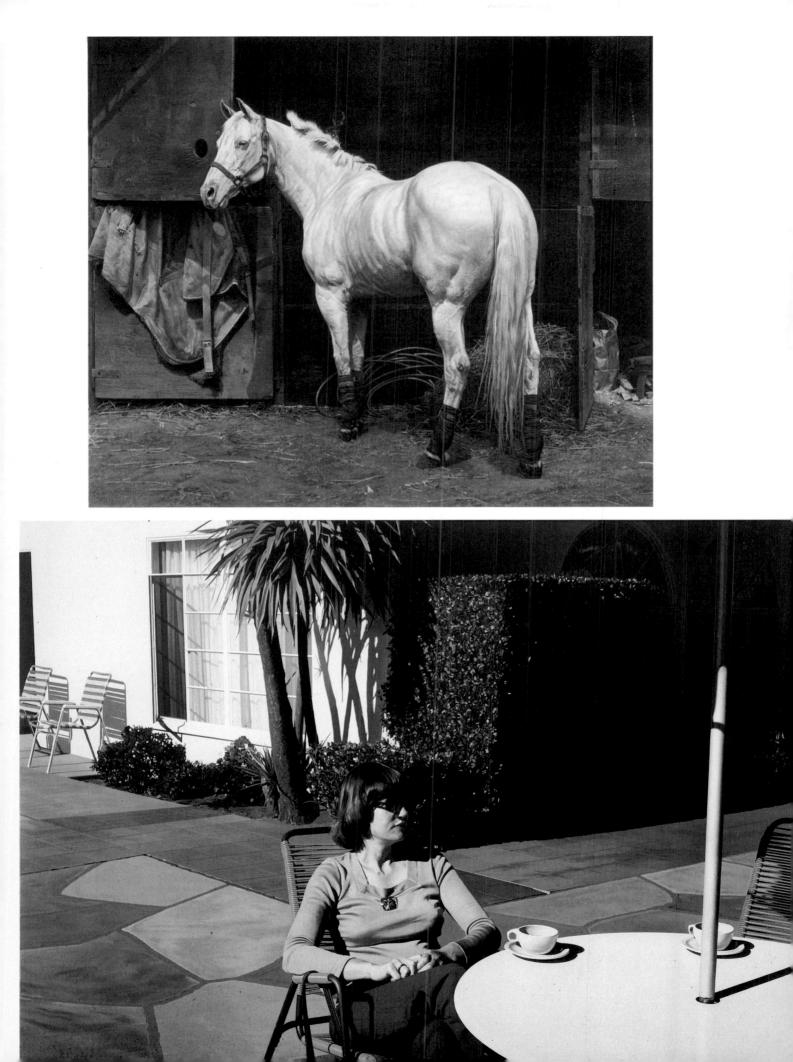

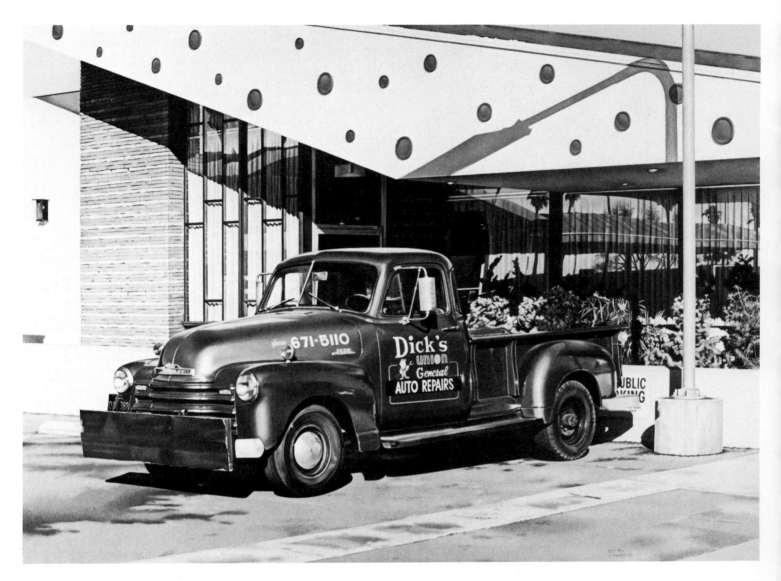

25. Ralph Goings (b.1928): *Dick's Union General*. 1971.
Oil on canvas, 101.6 × 142.2 cm. (40 × 56 in.) Richmond, Virginia, Collection of Mr and Mrs Sydney Lewis

23 (previous page, above). Richard McLean (b.1934):
Sheba. 1978. Oil on canvas, 127 × 155 cm. (50 × 61 in.)
New York, O.K. Harris Gallery

24 (previous page, below). Robert Bechtle (b.1932):
Santa Barbara Motel. 1977. Oil on canvas, 123.8 ×
175.3 cm. (48¾ × 69 in.) New York, O.K. Harris
Gallery

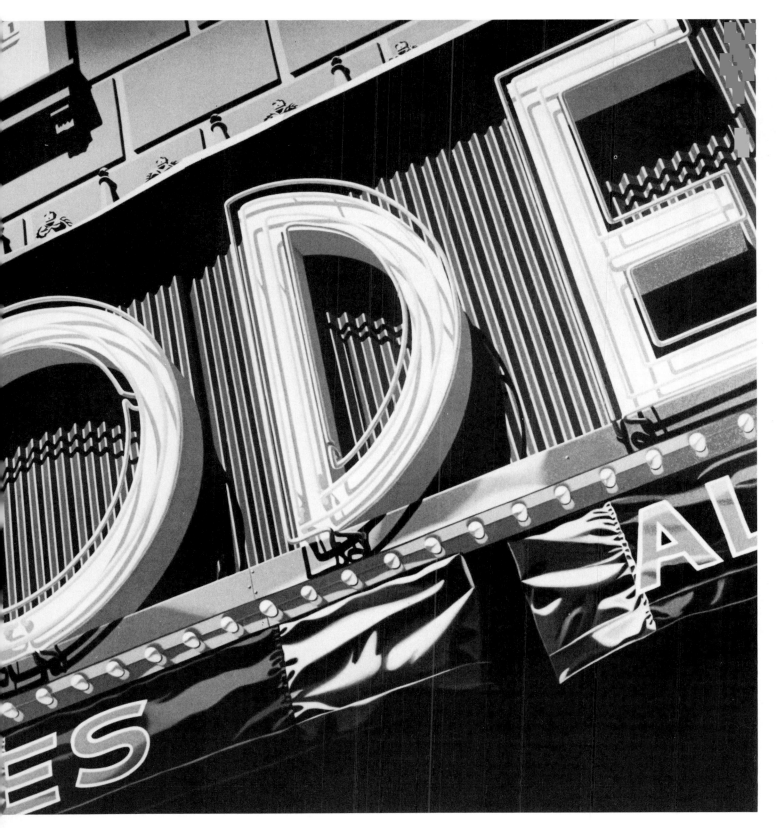

26. Robert Cottingham (b.1935): *Ode*. 1971.
Oil on canvas, 198 × 198 cm. (78 × 78 in.) New York, O.K. Harris Gallery

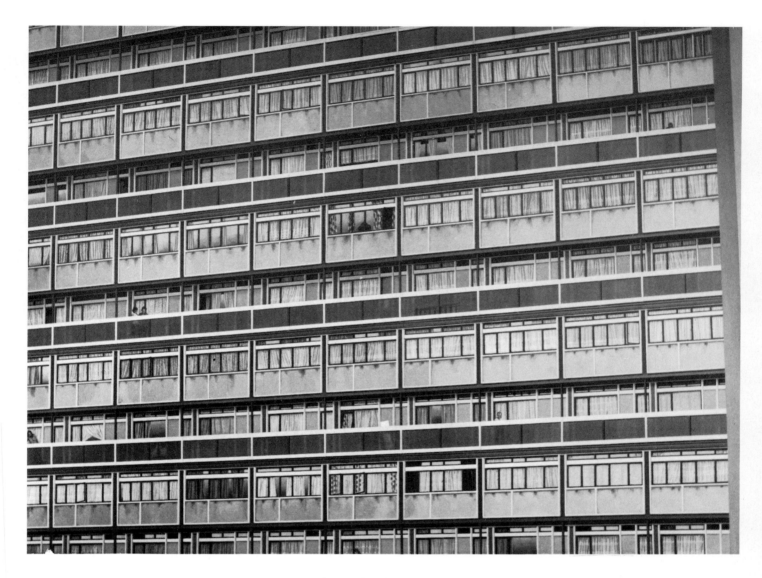

27. David Hepher (b.1935): *Peckham Flats*. 1976.
Acrylic on canvas, 193 × 274.2 cm. (76 × 108 in.) Collection of the artist

Similarly, it is interesting to compare a dior-
ama of the New York subway made by the
American Super Realist Richard Haas (Plate
29) with a painting entitled *On the Underground*
by the Spaniard Daniel Quintero (Plate 30).
Haas's work is sinister. The passengers
waiting on a sparsely populated platform seem
to symbolize the loneliness of big city life, and
the whole atmosphere conveys a feeling of
uncertainty and danger. Quintero treats the
same basic material in a diametrically opposite
way. Instead of putting the emphasis on

empty receding perspectives, he puts every-
thing as close as possible to the frontal plane
of the picture. Here one sees a crowded, old-
fashioned underground carriage, its paint
scarred by many years of hard use. Within it
are a tightly packed mob of rush-hour

28. Brendan Neiland (b.1941): *City Corner*. 1977.
Acrylic on canvas, 208.1 × 138.5 cm. (82 × 54½ in.)
London, Fischer Fine Art Ltd.

40

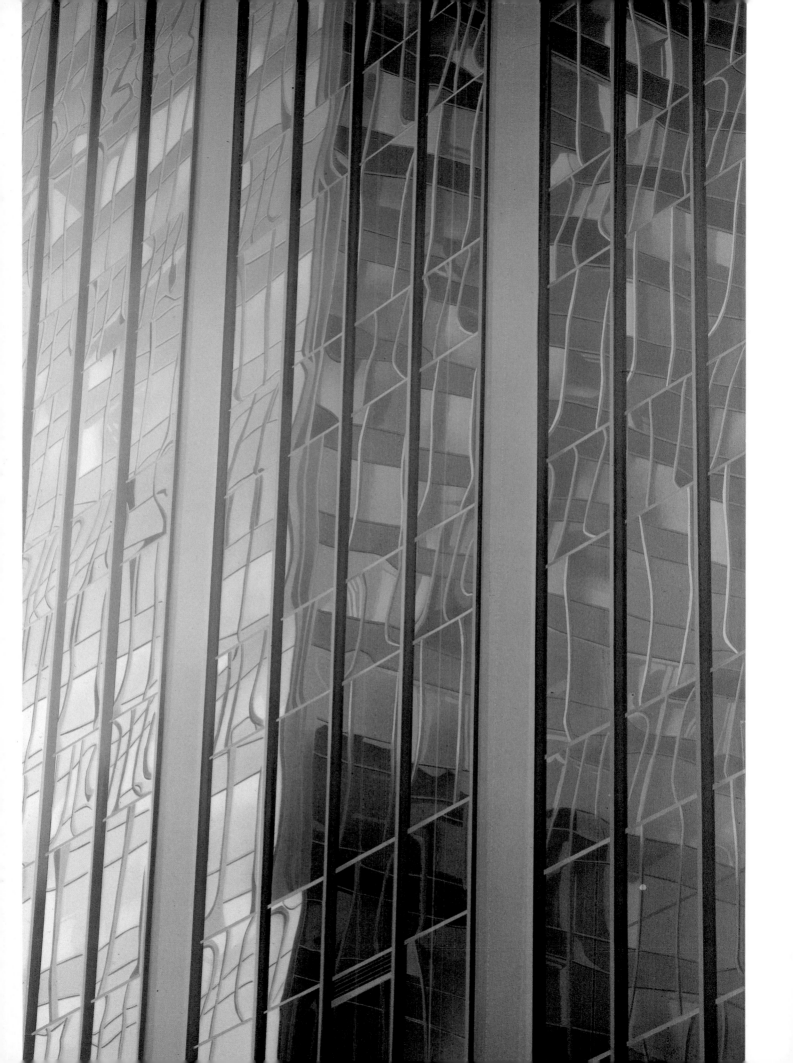

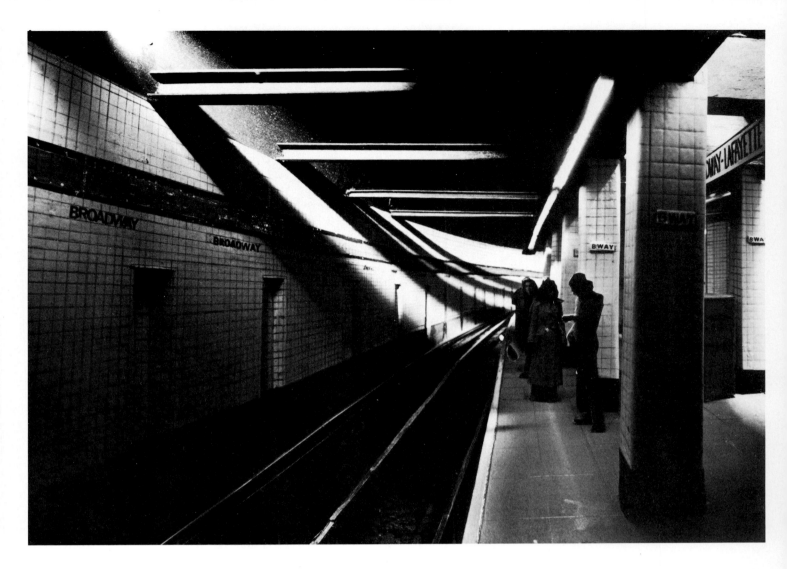

29. Richard Haas: *Subway*. 1971.
Dioramic box, mixed media, 38 × 68.6 cm. (15 × 27 in.) New York, Hundred Acres Gallery

passengers. One man puts the palm of his hand against the inside of the glass, and this palm is painted so that it seems to rest on the picture-plane itself. If the glass broke under the pressure put on it the man's arm would intrude into our space. It is not the loneliness of city life but its crowded discomfort and claustrophobia which are here emphasized.

Just as America possesses the largest number of Super Realist painters, so too it presents the widest range of subject-matter in Super Realist style. What the artists paint ranges across almost the whole gamut of the classical genres.

They produce still-lifes, landscapes and portraits, and occasionally what can perhaps be described as genre scenes. The only category to be almost absent is the history-picture, whose large aspirations are diametrically opposed to everything the new figurative painting stands for. Its place is taken, appro-

30 (opposite). Daniel Quintero (b.1949): *On the Underground*. 1972. Oil on wood, 200 × 130 cm. (78¾ × 51¼ in.) London, Marlborough Fine Art

31 (overleaf). John Salt (b.1937): *Lunch Room*. 1977.
Oil on canvas, 106.7 × 165.1 cm. (42 × 65 in.) New York, O.K. Harris Gallery

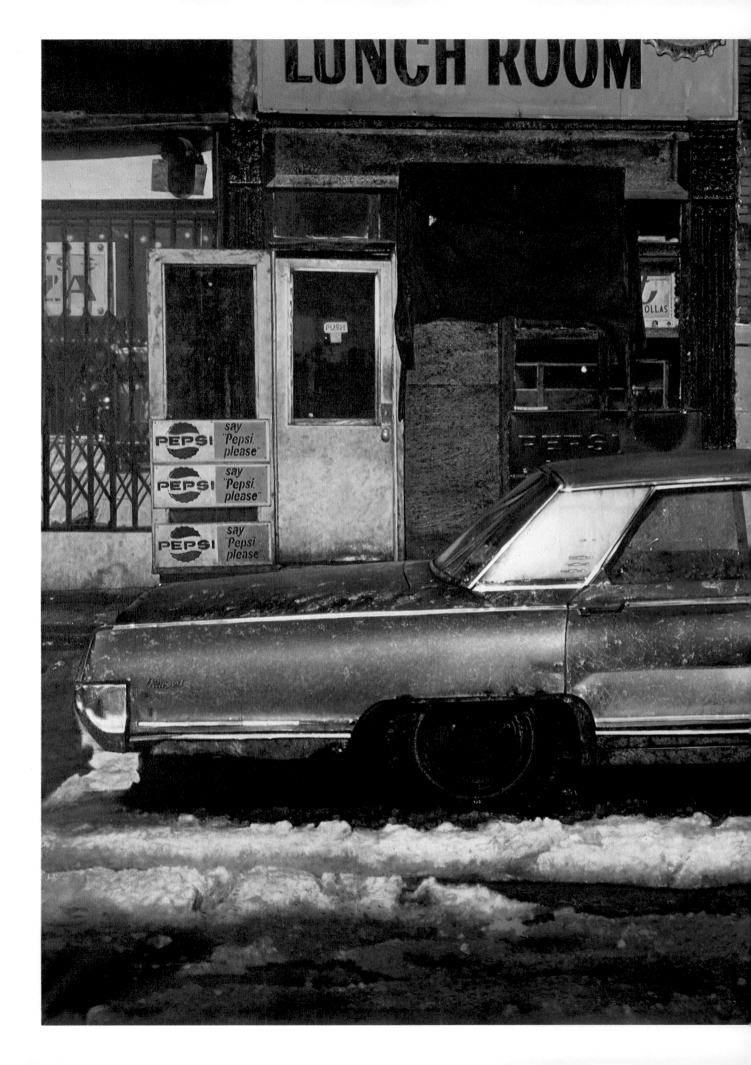

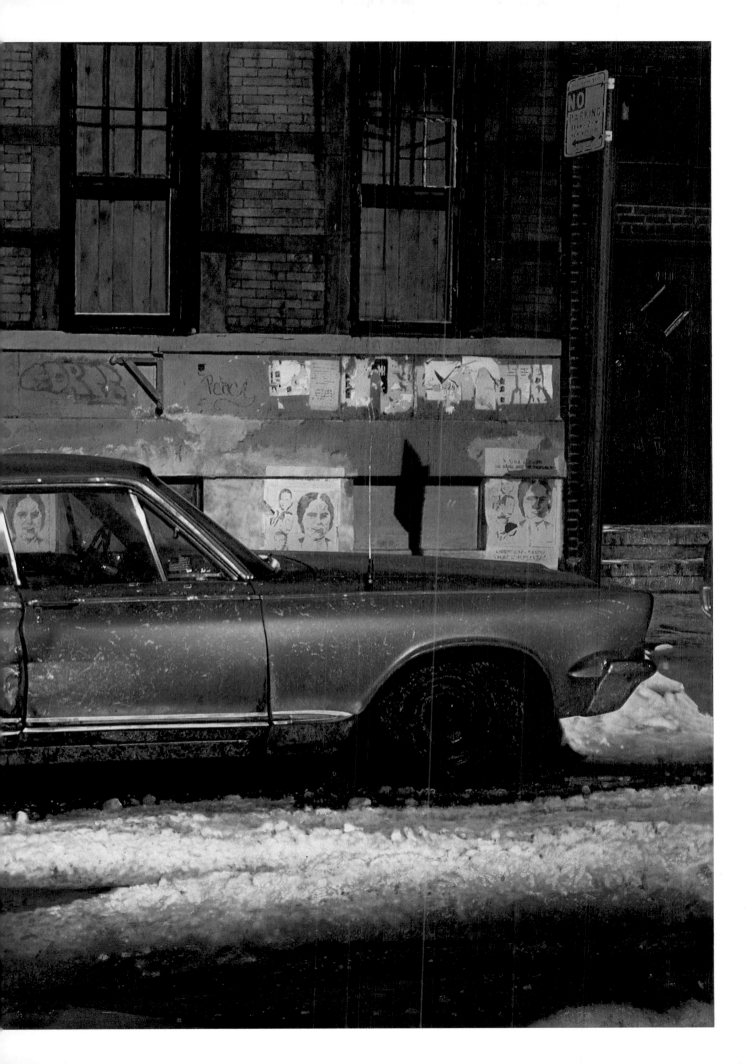

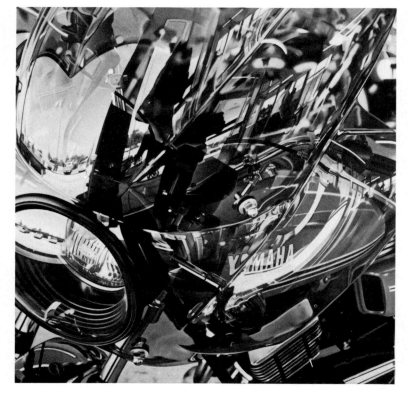

priately enough, by the kind of sarcastic parody of the Old Masters produced by John Clem Clarke.

In many ways, however, the categories have been transformed. Still-life, for example, may be altered in two different ways—by change of subject, or by an unexpected treatment of what is traditional. Super Realism is a mechanistic style, and it is therefore no surprise to discover that many of its practitioners are fascinated by machines. The automobile, besides figuring prominently in the work of the Californian group, is the chosen subject-matter of John Salt (Plate 31), who, like Morley, is English-born but domiciled in America. Salt gives what he paints a strangely melancholy air, since his automobiles are usually wrecks in a junkyard. Their dilapidation chimes with Super Realism's general air of disillusionment, but there is also an element of myth-making. These dead machines bear the imprint of human presence; the painter reacts almost voluptuously to the colours and textures of what he paints; and he implies by this reaction the kind of emotion one is also accustomed to discover, more conventionally presented, in the paintings of ruins by artists such as Hubert Robert.

It is nevertheless not the automobile which receives the full romantic treatment in Super Realist art, but the motor-cycle. Motor-cycles have become contemporary symbols of speed, freedom, danger and sexual potency. Several American artists have made a specialty of paintings showing motor-cycles and details of motor-cycles. Curiously enough, these are also the artists who tend to be particularly vehement about their indifference to their subject-

32. David Parrish (b.1939): *Yamaha.* 1978. Oil on canvas, 198.1 × 195.6 cm. (78 × 77 in.) New York, Nancy Hoffman Gallery

33. Don Eddy (b.1944): *Glassware I.* 1978. Acrylic on canvas, 132.7 × 101.6 cm. (52¼ × 40 in.) New York, Nancy Hoffman Gallery

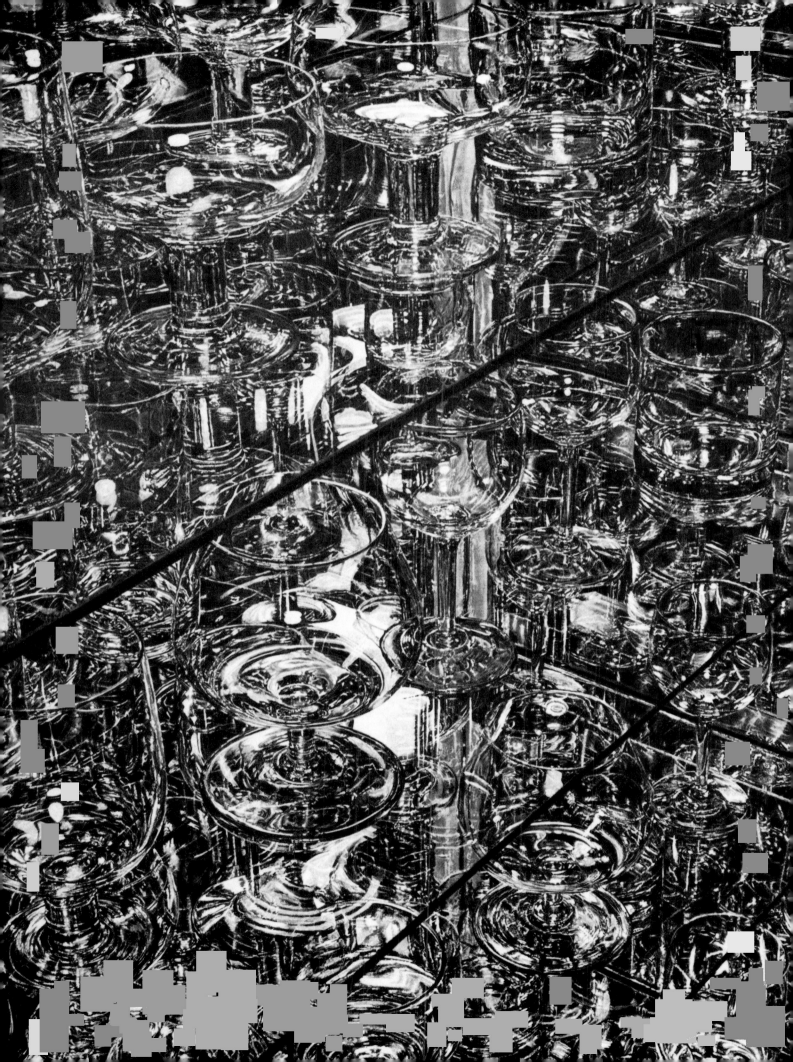

34 (top left). Tom Blackwell (b.1938): *Honda 750*. 1978. Oil on canvas, 167.6 × 213.4 cm. (66 × 84 in.) New York, Louis K. Meisel Gallery

35 (bottom left). Claude Yvel (b.1930): *Ariel 500*. 1972. Oil on canvas, 132.1 × 198.1 cm. (52 × 78 in.) Paris, Galerie du Luxembourg

36 (right). Claude Yvel (b.1930): *After the Race*. 1973. Oil on canvas, 53.3 × 45.7 cm. (21 × 18 in.) Paris, Galerie du Luxembourg

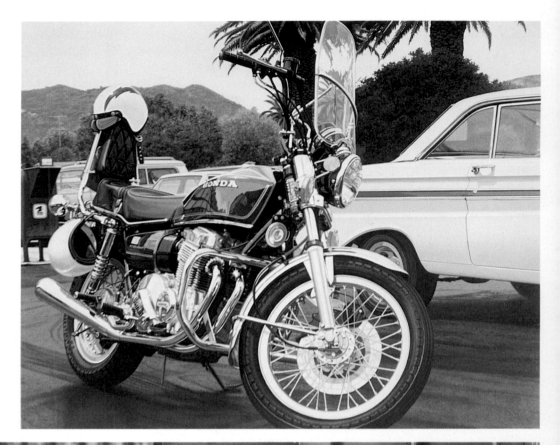

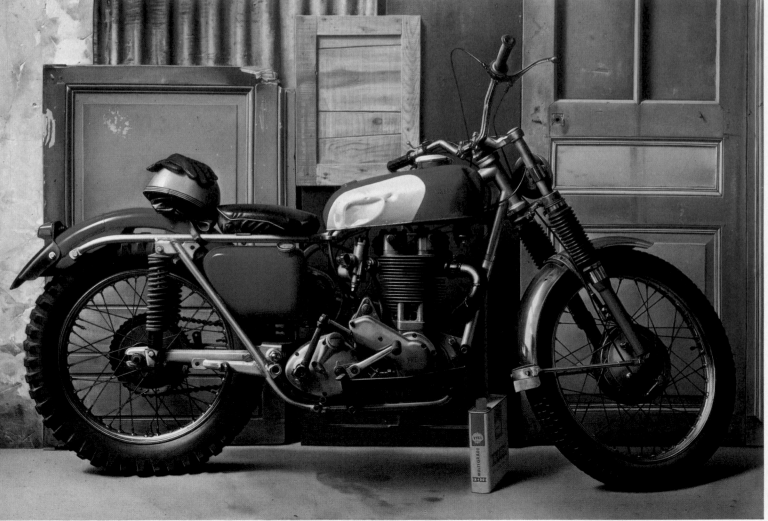

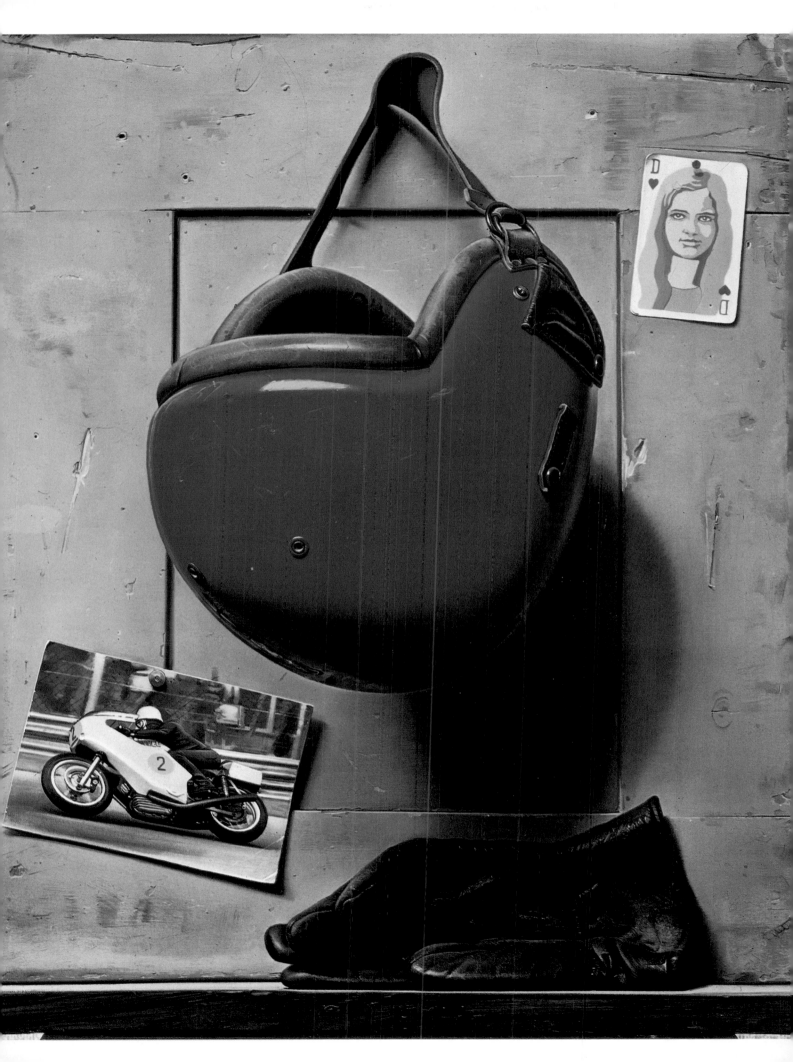

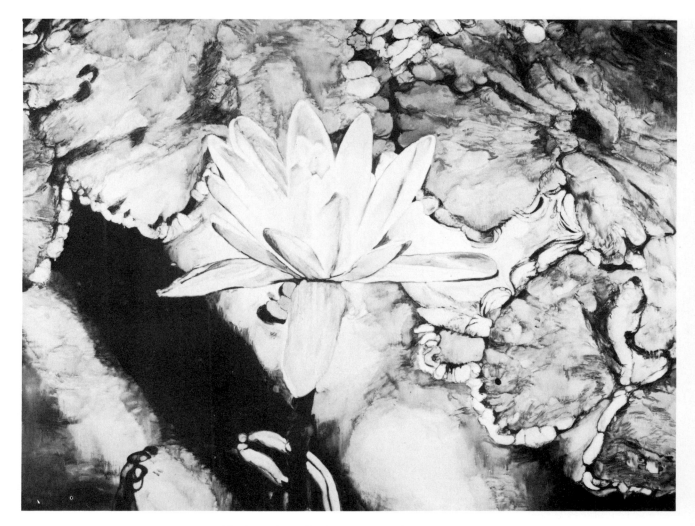

37. Joseph Raffael (b.1933): *White Lily*. 1977.
Oil on canvas, 167.6 × 228.6 cm. (66 × 90 in.) New York, Nancy Hoffman Gallery

matter. Don Eddy, who belongs to this group but also paints stunning still-lifes in which the same objects are repeated over and over (Plate 33), says: 'The central problem in the painting to me is a painting problem and not a subject-matter problem. It has to do with the relationship between the outside world, the surface of the canvas, and the kind of tension that is set up between illusionary space and the integrity of the surface of the canvas.' He adds that, for him, the imagery he uses becomes a kind of measuring stick for spatial tensions. Yet one is entitled to comment here that the motor-cycle pictures by Eddy and others present a perfect example of a recurrent phenomenon in art: that of the work which is meant to be construed in one way, but which none the less

insists on being read in another. Most paintings have both a text and a sub-text; and sometimes, as here, it is the unconsciously generated sub-text which governs the spectator's reaction.

It is particularly interesting to compare the motor-cycle paintings done by David Parrish (Plate 32) and Tom Blackwell (Plate 34) with those produced by the Frenchman Claude Yvel (Plate 35), as this comparison helps to spell out the difference between the American and the European approach to veristic art. Yvel is not relatively informal, like Blackwell, nor does he use the forced close-up like Parrish. His chosen viewpoint is consistently further away from the object he is painting, so that we have the opportunity to inspect it

50

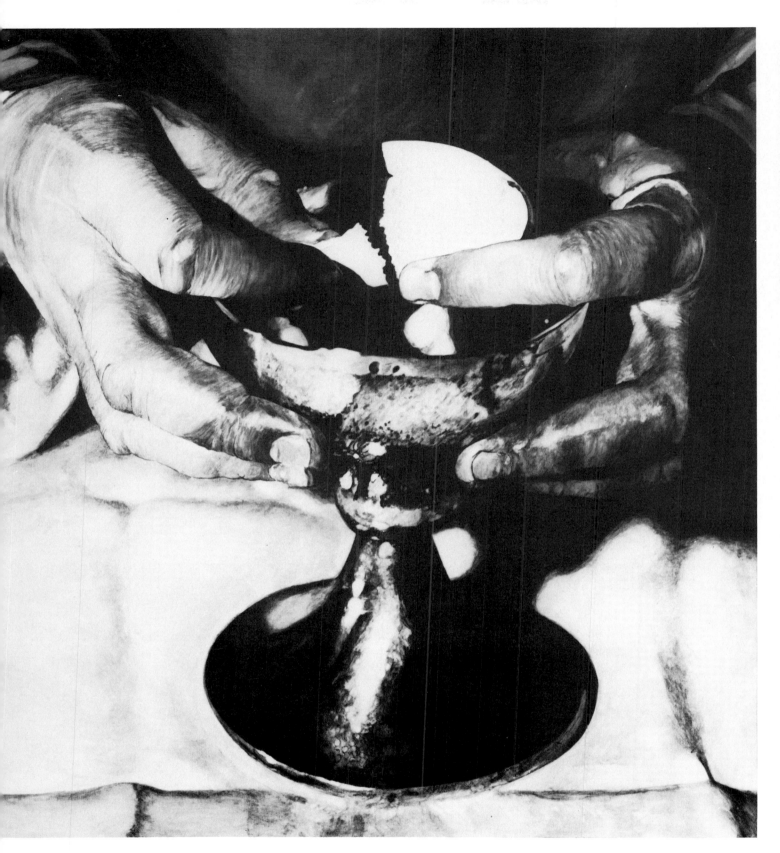

38. Joseph Raffael (b.1933): *Holy Communion*. 1968.
Oil on canvas, 154.9 × 154.9 cm. (61 × 61 in.) New York, Nancy Hoffman Gallery

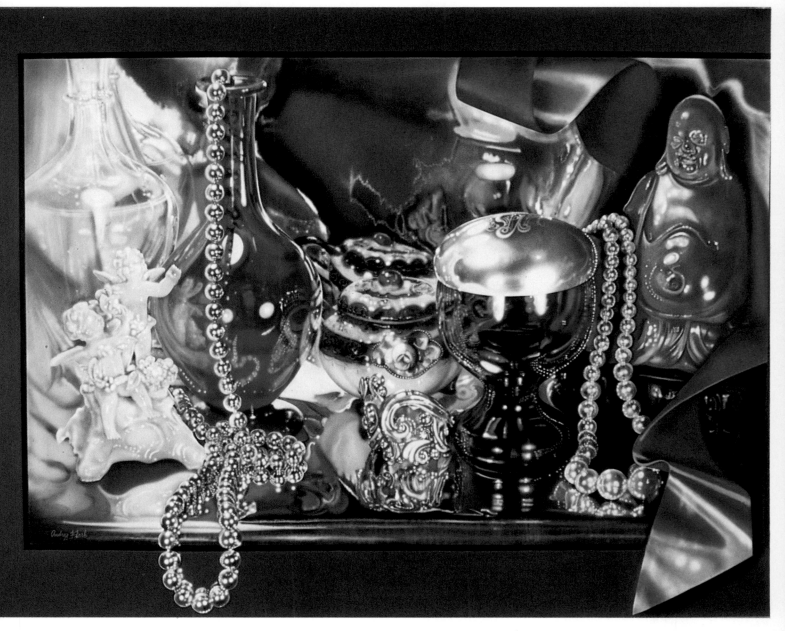

39. Audrey Flack (b.1931): *Buddha*. 1975.
Acrylic on canvas, 177.8 × 243.8 cm. (70 × 96 in.) New York, Louis K. Meisel Gallery

completely. When he wishes to invest his work with a certain obliqueness, he does it in a different and far more traditional way. Both he and Claudio Bravo have painted *trompe-l'oeil* still-lifes showing a motor-cyclist's accoutrements (Plate 36). These make conscious reference to similarly arranged paintings produced during the eighteenth and nineteenth centuries, which of course show a very different range of emblematic objects. This kind of historical allusion, despite the insistent presence of Harnett and his peers in the American tradition, is something which American Super Realists seldom bother to attempt.

40. Audrey Flack (b.1931): *Dolores*. 1971. Acrylic on canvas, 177.8 × 127 cm. (70 × 50 in.) New York, Louis K. Meisel Gallery

52

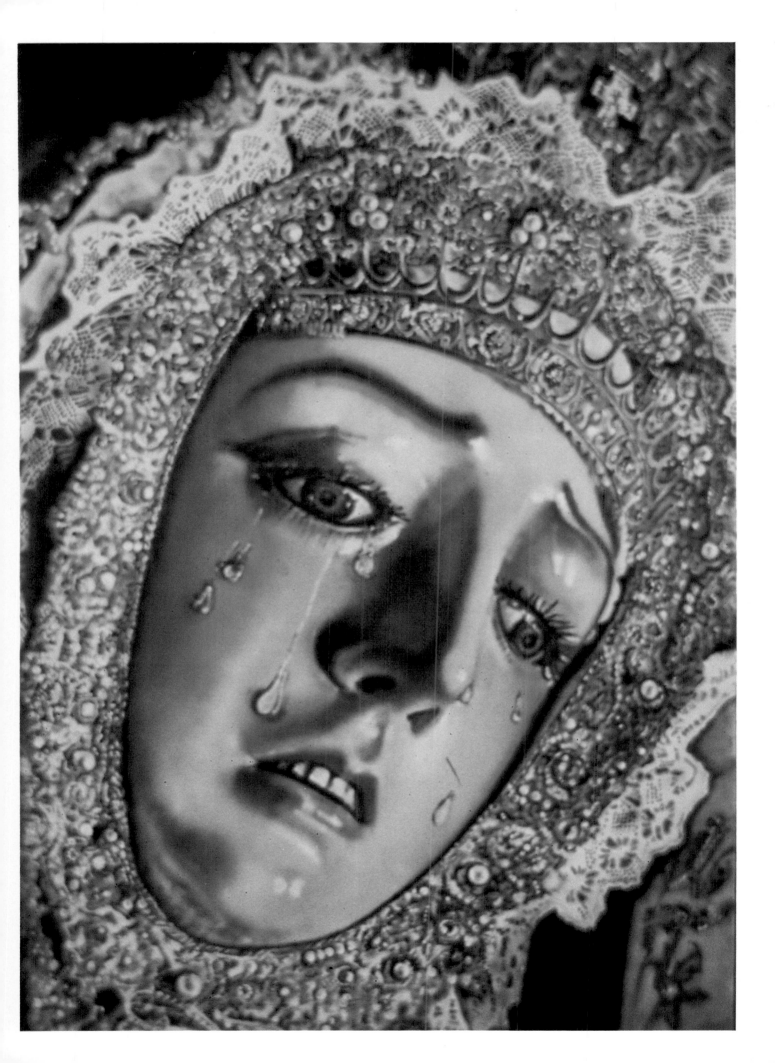

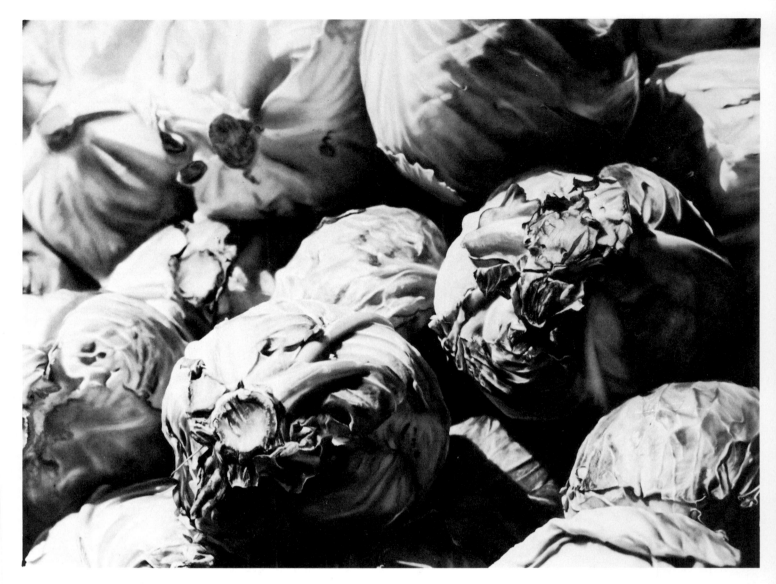

41. Ben Schonzeit (b.1942): *Cabbage*. 1973.
Acrylic on canvas, 203.2 × 274.2 cm. (80 × 108 in.) New York, Nancy Hoffman Gallery

Indeed, when they do address themselves to something where history plays its part, as in Audrey Flack's paintings of church images (Plate 40), their impulse is to heighten the immediacy of the spectator's experience, and his sense of its importance to himself, by means of an enormous close-up, which equates the statue with a film-star caught at some particularly important moment in the film narrative. Flack also manages to do the same thing with quite ordinary still-life accumulations (Plate 39). Joseph Raffael (Plates 37 and 38), one of the few Super Realist artists to take an interest in nature, uses an almost precisely similar technique when dealing with his own range of material. He says that his idea is to make pictorial equivalents for the creative principle which he discovers is the natural world, and says that the artist must be regarded chiefly as 'a conduit of information'. 'My major consideration', he wrote, in a statement published in 1975, 'is to express, through painting, a field of phenomena, found expressed in and through nature, but not limited to nature.' He sees the photographic image which serves as a basis for the work as 'a bridge of transport to a field of experience which before had been felt as the void but, on

54

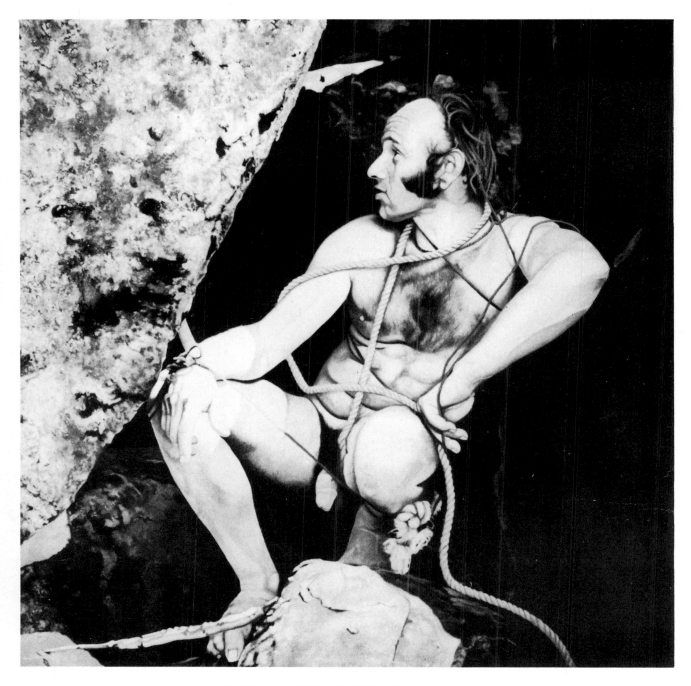

42. Mariann Miller (b.1932): *Man on Beach*.
Oil on canvas, 172 × 127 cm. (50 × 50 in.) New York, Stefanotti Gallery

the other side, for a moment becomes serenity.' It is, of course, true that this note of quasi-mysticism is rare among Super Realists taken in general. Flack, for example, says that her reason for using photographs as prime source material is simply that they offer her 'more time and a new kind of relaxed time' in which to get to grips with the subject.

I have already noted that the narrative conventions adopted by the Salon realists owed something to their experience of the theatre. American Super Realism, which, in theory at least, adopted an attitude of anti-theatrical passivity, is clearly deeply influenced by the cinema. A still-life of cabbages by Ben Schonzeit (Plate 41), for instance, uses not only the photographic devices of close-up and differential focus, but is composed in such a

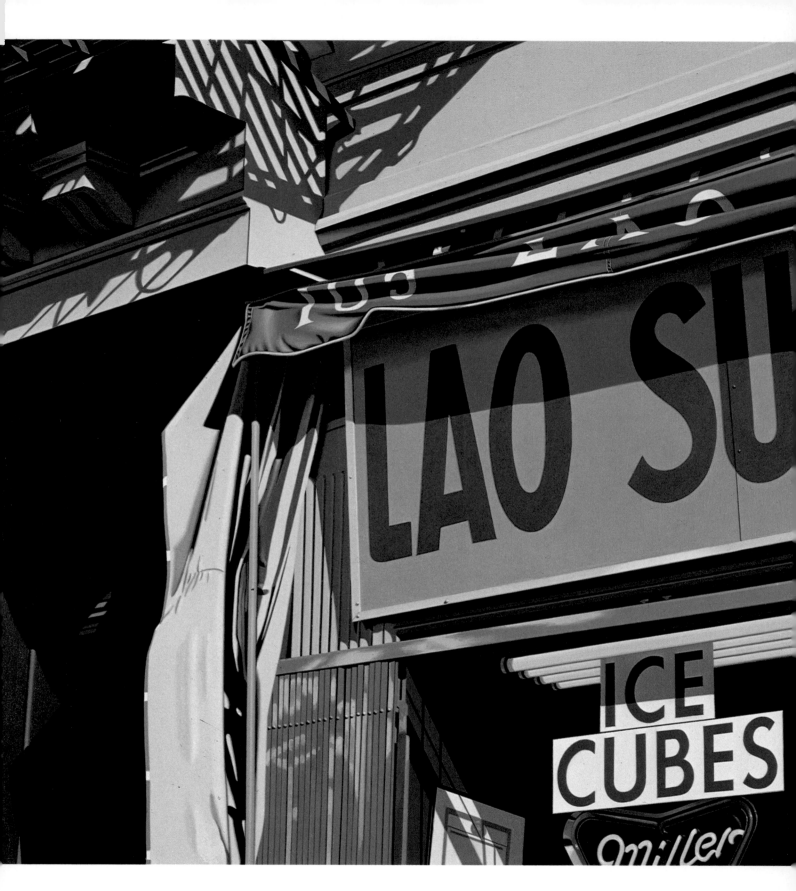

43. Robert Cottingham (b.1935): *Lao*. 1978.
Oil on canvas, 76.2 × 76.2 cm. (30 × 30 in.) New York, O.K. Harris Gallery

56

way as to suggest that the painting is a mere excerpt from something which has in fact been seen in a continuously flowing way. It is not merely a still-life, but a still from a film. This a-compositional quality can also, as it happens, be referred to another source. It links Super Realism to its own apparent opposite within the American art-world: one finds the same rejection of the boundary in the Post Painterly Abstractionists, such as Kenneth Noland. But this reference does not invalidate the other.

The cinematic feel of much Super Realist painting is matched by its covert inclination towards Surrealism. This can be detected, for example, in the mysterious roped figures painted by Mariann Miller (Plate 42), and in Stephen Posen's paintings of boxes covered by drapery. Posen, like many American Super Realists, tends to emphasize the role of the painting as a repository for factual information. 'I think,' he says, 'if there is one thing that is consistent with all the New Realist painters it is a concern for an accumulation of information.' He also makes much play with the sheer laboriousness of his own method of work, which in his case has nothing to do with the camera: 'I use an industrial fork-lift device on wheels wired for up and down movement and equipped with a seat and a palette.' He says nothing about the symbolism of his shrouded objects, though for the spectator this must inevitably impinge. What mystery is being so deliberately concealed?

The relationship to veristic Surrealism is the thing which, at a first glance, seems to bind American Super Realism most closely to its European counterpart. It is perhaps no accident that Howard Kanovitz (Plate 44), one of the Americans most inclined to adopt surrealist ideas and devices, has in fact spent a substantial part of his career living and working in Europe. Yet, as the comparison with Kanovitz himself will show, European artists retain a strongly traditional element, which marks them

44. Howard Kanovitz (b.1929): *East Side Still Life*. 1978. Pastel, 111.8 × 76.2 cm. (44 × 30 in.) New York, Collection of the artist

57

45. Fernando De Filippi (b.1940): *Lenin during his Visit to Capri, where he was a Guest of Maxim Gorki, 1908*. 1972.
Acrylic, 140 × 140 cm. (55 × 55 in.) Milan, Galleria Arte Borgogna

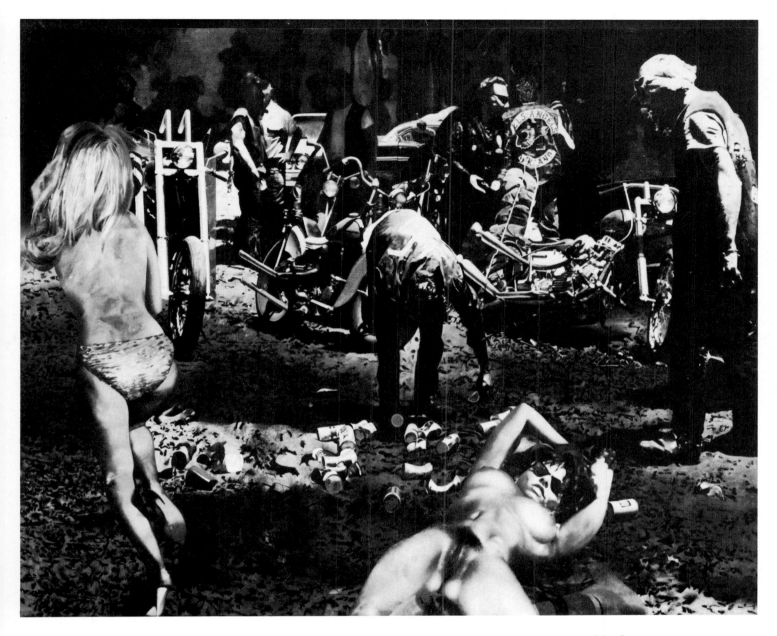

46. John-e Franzen (b.1942): *Hell's Angels of California, United States of America*. 1966–9.
Acrylic on canvas, 165 × 213 cm. (65 × 84 in.) Stockholm, Moderna Museet

off from their transatlantic counterparts. This traditionalism shows itself in a number of different ways. The Italian painter De Filippi, for instance, uses the photo-realist convention as the basis of one of the few history paintings illustrated in this book. His *Lenin during his visit to Capri, where he was a guest of Maxim* *Gorky, 1908* (Plate 45), is apparently painted without irony, as a revolutionary icon. A similar didacticism can be found in a painting by the Swedish artist John-e Franzen entitled *Hell's Angels of California, United States of America* (Plate 46). But here one can also trace a relationship to Andy Warhol's *Disaster*

47. Franz Gertsch (b.1930): *Les Saintes Maries de la Mer*. 1971.
Oil on canvas, 300 × 400 cm. (118 × 158 in.) Paris, Galerie des Quatre Mouvements

48. Franz Gertsch (b.1930): *Making Up*. 1975.
Acrylic on cotton, 234 × 346.5 cm. (92 × 136¼ in.) Cologne, Wallraf-Richartz Museum

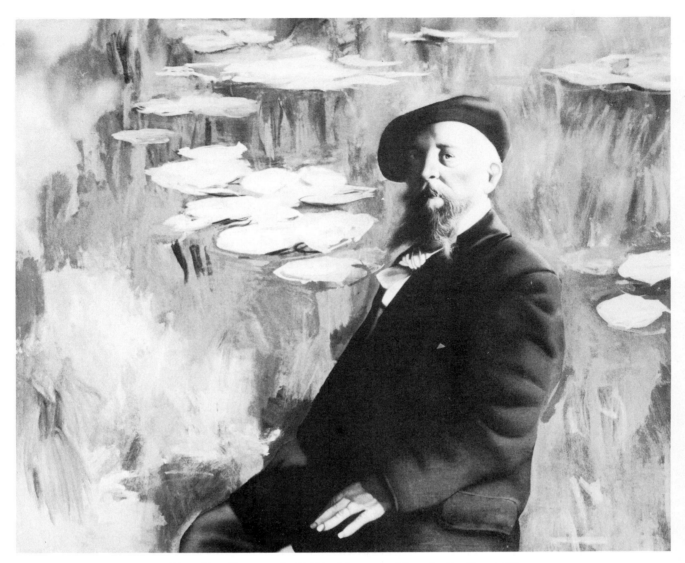

49. Mike Gorman (b.1938): *Monsieur Monet's Garden*. 1973.
Aquatec on canvas, 121.9 × 152.4 cm. (48 × 60 in.) London, Nicholas Treadwell Gallery

paintings, similarly based on news photographs. A more ambiguous social realism can be found in Michael Leonard's *Scaffolders* (Plate 15), which has already been mentioned. This combines a wry salute to the dignity of labour with a touch of homo-eroticism—a potent and largely literary amalgam. Franz Gertsch, in the *Making Up* paintings (Plate 48), conveys the perversely erotic in more specific fashion than Mariann Miller (his compositions can be read no other way, hers allow a number of different interpretations). In *Les Saintes Maries de la Mer* (Plate 47), on the other hand, the same artist seems to offer something which comes very close indeed to the naturalist Salon painting of the nineteenth century, when almost identical subject-matter was in favour. Mike Gorman, in *Monsieur Monet's Garden* (Plate 49), allows himself a different kind of reference to the past, showing the figure of the painter, done in impeccably academic style, against a background which is a 'photographic' copy of one of the late Monet paintings of waterlilies. One could multiply examples of this kind of nostalgic reference in European realist art. Paul Roberts (Plate 50)

50. Paul Roberts (b.1948): *Hors d'Oeuvres*. 1977.
Oil on canvas, 168 × 137 cm. (66½ × 54 in.) London, Nicholas Treadwell Gallery

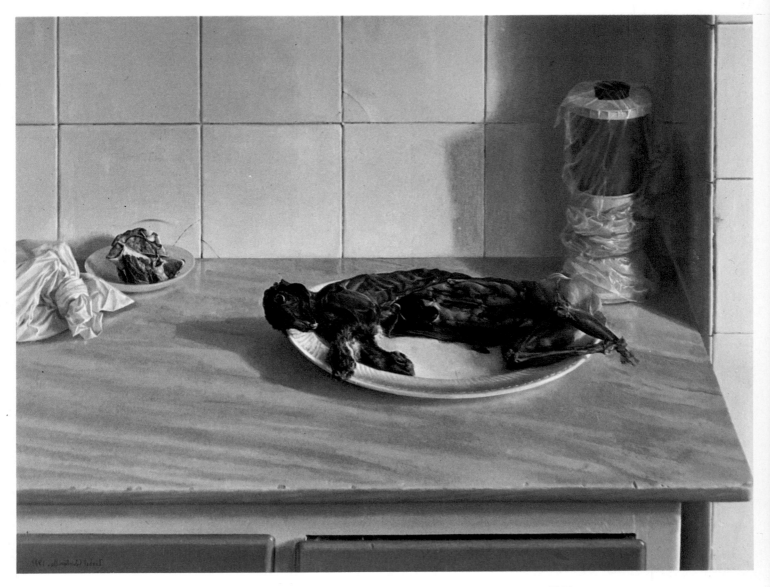

51. Isabella Quintanilla (b.1938): *Bodegon con Conejo*. 1971.
Oil on wood, 60 × 80 cm. (23½ × 31½ in.) Frankfurt, Galerie Herbert Meyer-Ellinger

who, like Mike Gorman, exhibits with Nicholas Treadwell, evokes, not cinematic techniques in general, but the Hollywood movies of the forties. The Spanish artist Isabella Quintillana alludes to the *bodegones* of the seventeenth century, in a way which teeters on the very brink of pastiche (Plate 51).

52. Dionigi Bussola (d.1687): *The Canonization of St Francis*. Mixed media, lifesize. Orta, Sacro Monte, Chapel No. 20

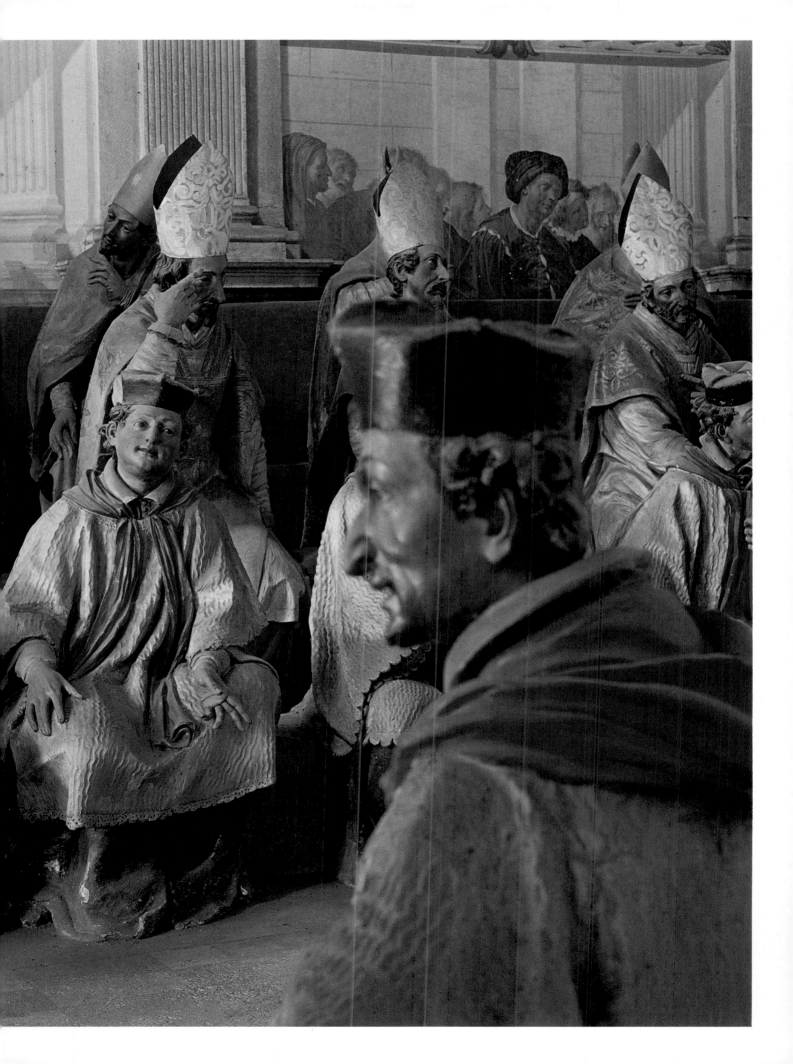

V

A discussion of Super Realist painting must necessarily differ from a discussion of Super Realist sculpture, because a painting is always, whatever its other characteristics, a translation of three dimensions into two. Super Realist sculpture, on the other hand, is a simulacrum, something which attempts to break down the barrier between art and life. Simulacra have a long but uneasy history in Western art. In Greek and Roman times, for example, lifesize sculpture in marble was frequently tinted to look real. In the Middle Ages, lifelike lifesize effigies were carried in the funeral processions of important persons, and the custom continued for some centuries thereafter, as is shown by the figures of English kings and queens preserved in the museum at Westminster Abbey. During the sixteenth and seventeenth centuries veristic figures were

made as part of the decoration of pilgrimage chapels in north Italy, such as those at Orta (Plate 52). A visit to a chapel on one of the sacred mounts was meant to give the pilgrim the illusion that he was actually present at some event in a saint's life, or in the gospel story. The tradition continued in the next century with polychrome marble sculpture like the effigy of St Stanislas Kostka in S. Andrea al Quirinale in Rome (Plate 53). Spanish religious sculpture of the Baroque period, naturalistically carved and painted, equipped with glass eyes and garments made of real cloth, was similarly meant to excite the worshipper's emotions by enabling him to see sacred events and personages with the eyes of the body. But the secularizing tendencies which manifested themselves all over

53. Pierre Legros the Younger (1666–1719): *The Blessed Stanislas Kostka*. Coloured marble, lifesize. Rome, S. Andrea al Quirinale

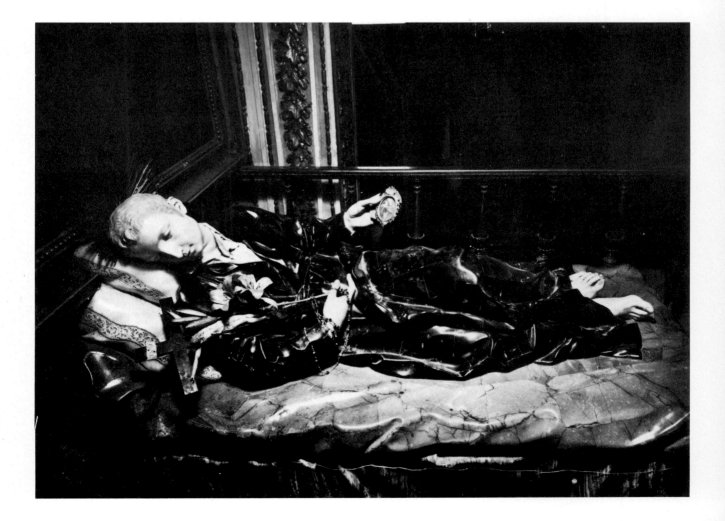

Europe in the course of the eighteenth century were felt in this sphere also. Mme Tussaud became famous for her waxworks, often with masks cast *ad vivum* from the features of those whom they represented; and it was Mme Tussaud who, during the Revolution, was forced to make death-masks of the most eminent victims of the guillotine.

At this period, however, and still more so during the nineteenth century, there was a rigid aesthetic distinction made between work of this type and anything which could be described as art. Rodin attracted criticism because it was believed that he had moulded some portions of his *Age of Bronze* direct from the body of his model.

Simulacra made a tentative reappearance thanks to Pop Art. In part this was due to the cult of anti-art which motivated Jasper Johns's well-known facsimile sculpture of two beer cans (Plate 56). Another impulse came from an interest in three-dimensional advertising signs (Oldenburg's giant hamburgers, for instance, have direct popular prototypes); and yet another can be traced to the need to make convincing three-dimensional props for various Pop Art happenings. The simulated food Oldenburg made for his happening *The Store* in 1965 was subsequently promoted to the rank of work of art.

It is, however, customary to locate the real beginnings of Super Realist sculpture in America in the work of George Segal (Plate 57). Segal makes moulds from the bodies of his models, and these moulded pieces are subsequently assembled to create figures which are then surrounded with 'real' settings and props. But the figures themselves make no attempt to counterfeit life. The plaster is left rough and white, and they remain ghostly visitants to their surroundings. Segal's way of making sculpture did, however, indicate a direction which was taken up by two other American artists, Duane Hanson (Plate 55)

54. Mark Prent (b.1947): *Hanging is very Important*, detail. 1972. Mixed media, polyester, resin, fibreglass, 243.8 × 243.8 × 243.8 cm. (96 × 96 × 96 in.) Toronto, Isaacs Gallery Ltd.

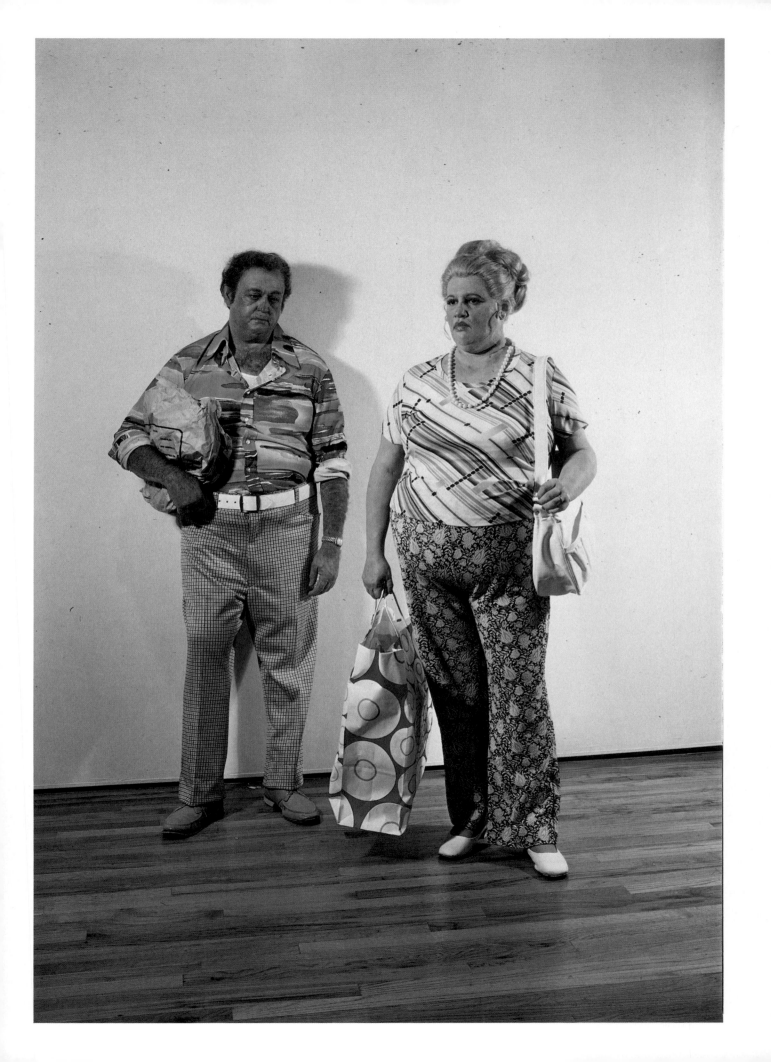

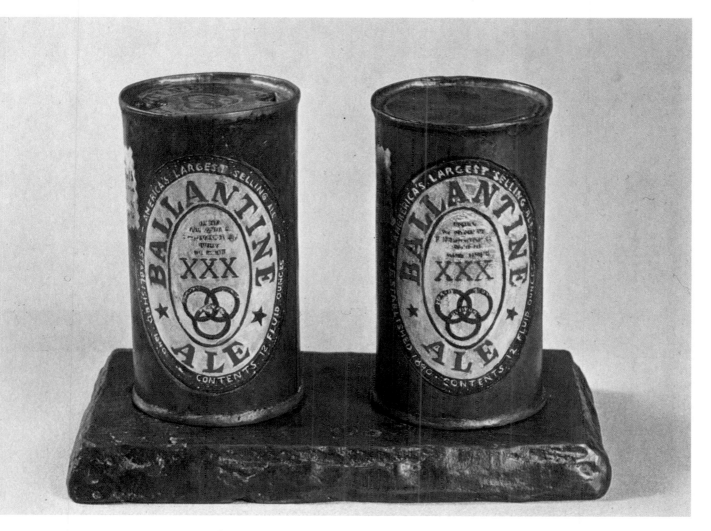

56. Jasper Johns (b.1930): *Painted Bronze II: Ale Cans.* 1964.
13.7 × 20 × 11.2 cm. (5⅜ × 9 × 4 in.) New York, Collection of the Artist

and John de Andrea; it is they who have been responsible for creating some of the most startling of all Super Realist works.

Hanson, unlike the majority of his Super Realist colleagues, admits that his work has a social message. Early sculptures, such as *Race Riot* and *Bowery Bums*, were angry statements about the nature of American society, and, while technically they owed much to Segal, their emotional thrust was more like that to be found in the work of Edward Keinholz, whose semi-surrealist environments were often cries of pain and rage at social

55. Duane Hanson (b.1925): *Couple with Shopping Bags.* 1976. Cast vinyl, polychromed in oils, lifesize. New York, O.K. Harris Gallery

injustice. Keinholz has more than a touch of *grand guignol*, and this is also present in early Hanson, though it does not appear as crudely or insistently as it does in the work of the Canadian Super Realist Mark Prent (Plate 54). Prent, for example, once made an elaborate semi-environmental piece showing human joints and carcasses for sale in a cannibal butcher's shop, something very much in direct line of descent from the traditional wax-museum Chamber of Horrors.

As he has developed, Hanson has become more relaxed and ironic. His realistically clothed and painted life-size figures, are portraits of middle- and lower-class American types. His gift is for creating effigies which might for a moment convince us that they are

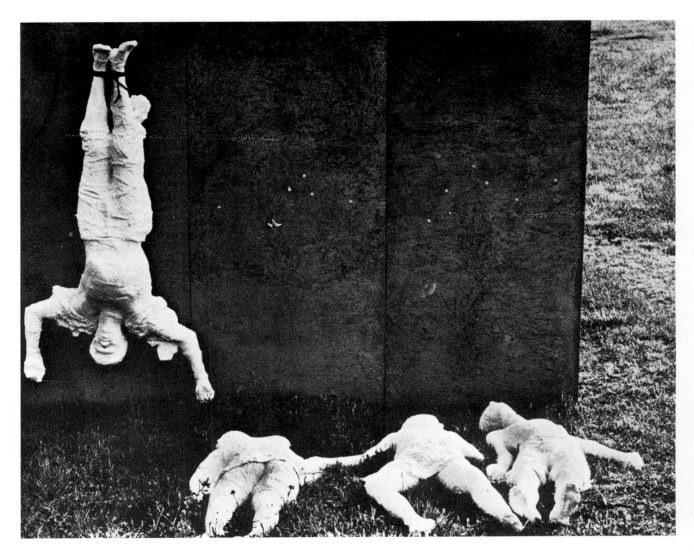

57. George Segal (b.1924): *Execution*. 1967.
Plaster, rope, metal, wood, 243.8 × 335.2 × 243.8 cm. (96 × 132 × 96 in.) Vancouver Art Gallery

living people but which, at a second glance, reveal themselves to be distillations, things which make a considered statement about a whole group or category of people. Indeed, they sometimes actually define that category and make us aware of its existence.

John de Andrea (Plate 59), the other leading American Super Realist sculptor, is like Hanson in that he moulds his figures from life, and then carefully paints them to resemble nature. But in almost every other respect his work is different. De Andrea shows his figures nude, sometimes in repose, but often engaged in violent activity—so violent indeed that the groups he composes seem, when photographed, more like stills from a film than actual

three-dimensional objects. The people he chooses to depict are for the most part American college types, recognizably so from their features and expressions as well as from other details such as their hair-styles. The sculptor seems to be putting forward the idea that these young people are representative of some modern ideal of beauty, playing the same role in today's art as the youths and maidens of Greek archaic and early classical sculpture. But this is undermined, whether deliberately or not, by departures from the accepted norms of beauty imposed by the moulding process; and it is damaged still more by a constant vapidity of pose and expression. The sculptures do have a certain eroticism, but this,

interestingly enough, is much less intense than the eroticism of the miniature wax nudes engaged in various mysterious occupations made by Robert Graham. Graham's nudes, enclosed in perspex, acquire, both because of this and because of their minuscule scale, the power to turn us all into voyeurs. De Andrea drains the nude of its power either to excite or to threaten.

If one compares Hanson and De Andrea with their European equivalents an immediate difference appears which is much more striking than the difference between European and American Super Realist painters. The nearest thing to American veristic sculpture now being done in Europe is what is being done in Mme Tussaud's studios, as new celebrities in wax join the ranks of those already immortalized. But, since the days of the foundress, there has been a loosening of style. The artists employed by the firm no longer make moulds from the life, but model free-hand, though still aiming for a totally lifelike effect. Their products are variable in quality, but some, such as a portrait of the aged Picasso (frontispiece), have a vividness and a personality which entitles them to be looked at as full-fledged works of art. Indeed, since they are now usually freer and more impressionist in method, these wax portraits are often closer to traditional sculpture than anything produced by either Hanson or De Andrea.

Quite apart from this, there is a small group of young sculptors in England who produce life-size veristic figures. The best known are John Davies (Plate 60), perhaps the most exciting young artist to have emerged in England during the 1970s, and Malcolm Poynter (Plate 58), a leading member of Nicholas Treadwell's realist stable. Davies and Poynter have a good deal in common. Their figures, though veristic, seem to inhabit a different, purely metaphysical world, symbolized by the strange props and accoutrements

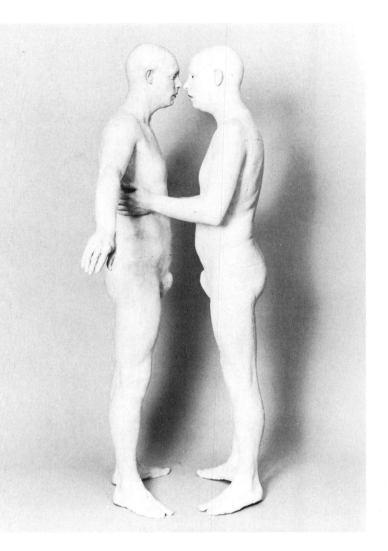

58. Malcolm Poynter (b.1946): *Portrait*. 1978. Fibreglass, lifesize. London, Nicholas Treadwell Gallery

71

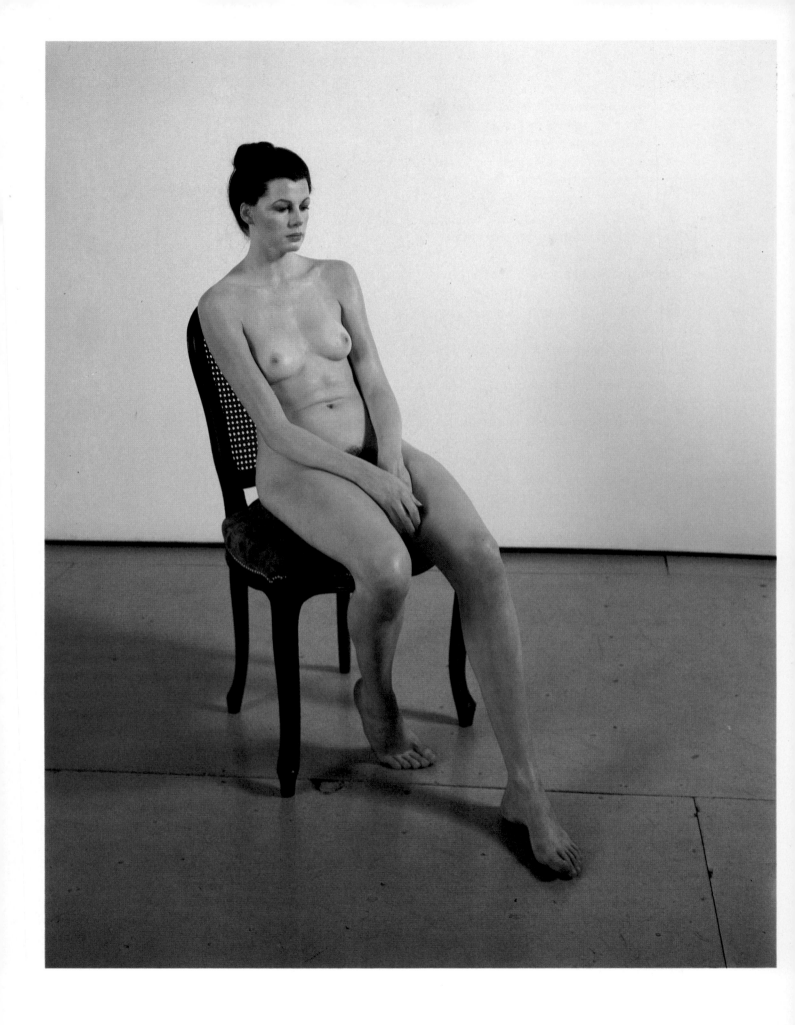

that surround and accompany them. Poynter's sculptures tend to be almost entirely unpainted, but the eyes are inserted, and certain details are slightly tinted. Davies makes more use of colour, but the hues of life are translated into greyed-back, ashen tones which make the figures seem like embodiments of some especially depressing dream. Often the effect of horror is accentuated by distortions or deformities—strange nasal excrescences, horns growing from the centre of the head. Originally the garments in which the figures were clothed were made of ordinary cloth, but in more recent work this has been stiffened and painted to make flesh and clothing seem like different versions of the same ectoplasmic substance.

It is perhaps surprising that Super Realist sculptors have not made more use of clay, since this is a tractable and durable material which, once fired and glazed, has lifelike colour and permanency. In America, the leading Super Realist sculptor using this material is Marilyn Levine (Plate 63), whose work will be discussed in a moment. In Communist China there is the extraordinary *Rent Collection Courtyard*, an assemblage of figures made of unbaked clay which, both in style and in didactic purpose, greatly resembles the figures in the chapels at Orta. And in Europe there are the beautiful and disturbing male torsos produced by the Dutchman Jan van Leeuwen (Plate 62). These torsos are not nude, but are clad in singlet and shorts. Despite their lack of colour, they have an extraordinary verisimilitude. In creating these

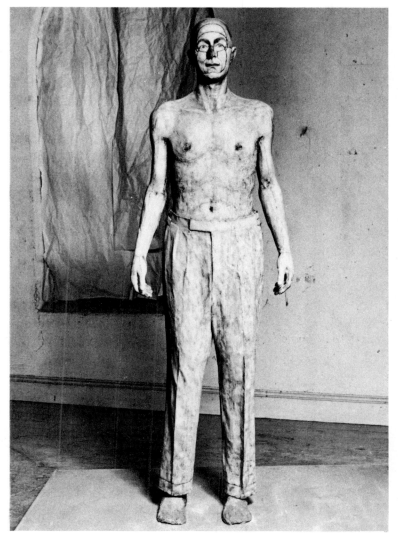

59. John de Andrea (b.1941): *Seated Woman*. 1978. Polyvinyl polychromed in oil, lifesize. New York, O.K. Harris Gallery

60. John Davies (b.1946): *Pupil*. 1973–5. Mixed media, lifesize. Collection of the artist

61. Francisco López (b.1932): *Still Life with Quinces*. 1973.
Bronze, 23 × 53 × 67 cm. (9 × 20⅞ × 26⅜ in.) London, Marlborough Fine Art

pieces, van Leeuwen shows a typically European consciousness of the burdens imposed by the past. They refer back to the cult of the antique fragment which has existed in Europe since the Renaissance. Yet the presence of clothing, and the extraordinary fidelity with which every fold and wrinkle, every detail of texture can be reproduced in clay, gives them a more powerful eroticism than the wholly naked figure might possess.

Contemporary Spanish artists, such as Antonio Lopez-Garcia and Francisco López (Plate 61) have tried to revive the specifically Spanish veristic tradition, working in bronze but also in wood; but the use of these somehow 'expected' materials, with their fine-art associations, leads to results very unlike van Leeuwen's, and somehow not far removed from the academic sculpture of the nineteenth century.

In Germany the Critical Realist trend has produced sculpture as well as painting. The

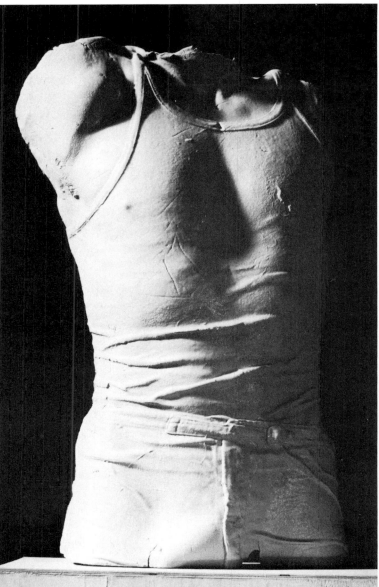

62. Jan van Leeuwen (b.1943): *Torso*. 1977. Ceramic, lifesize. Collection of the artist

most interesting work in three dimensions is by two women—Christa Biederbick-Tewes, and the Czech-born Ludmila Seefried-Matějková. The latter's *Cry I* (1975)—a caged man uttering a howl of rage and frustration, is one of the most powerful, if certainly not the subtlest, sculptural images of the decade (Plate 64).

One consistent feature of Super Realist sculpture, in line with the emphasis placed on still-life in Super Realist painting, has been the faithful reproduction of inanimate objects, whether natural or man-made. This involves, not the transmutation of forms, which is the traditional business of sculpture, but the simple transposition of material. The exercise has been sporadically undertaken in the post-war period by artists who have never been called Super Realist. Jasper Johns's beer cans and Oldenburg's imitation food both fall into this category. So do the still-lifes in bronze by the Italian sculptor Manzù and some at least

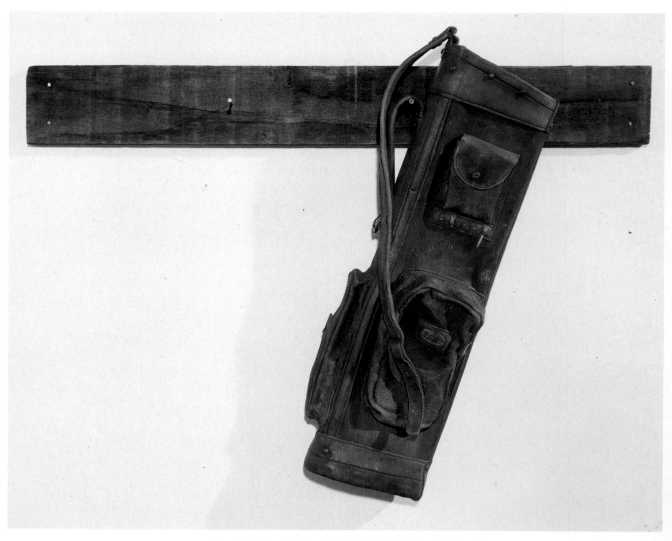

63. Marilyn Levine (b.1933): *Golf Bag*. 1976.
Ceramic, 86.4 × 27.9 × 12.7 cm. (34 × 11 × 5 in.) New York, O.K. Harris Gallery

of the chromium-plated works by the English-man Clive Barker, though in these cases there is no attempt to disguise the change in material. Francisco López follows closely in Manzù's footsteps with his bronze still-life of quinces (Plate 63), which seems to be a worked-up cast made from the original arrangement of fruit, crockery and other objects.

The most consistently veristic sculptures in the whole Super Realist spectrum are, un-doubtedly, the ceramics of Marilyn Levine (Plate 63). These transpose objects made of leather, or leather and canvas, into terms of baked and painted clay and, astonishingly enough, no moulding process is involved in making them—they are modelled free-hand.

Yet these three-dimensional *trompe-l'oeil* objects bear such a startling resemblance to their originals that it is only when one touches or tries to pick them up that one realizes the deception. The impact of Marilyn Levine's work, however, is such that it is clearly more than a trick. Her objects are affecting indirect portraits of those who have used and handled them. She herself says: 'My work is involved with a story of the individual and the use of

64. Ludmila Seefried-Matějkova (b.1938): *Cry I*. 1975. Fibreglass, lifesize. Collection of the artist. Courtesy the Institute of Contemporary Arts, London

76

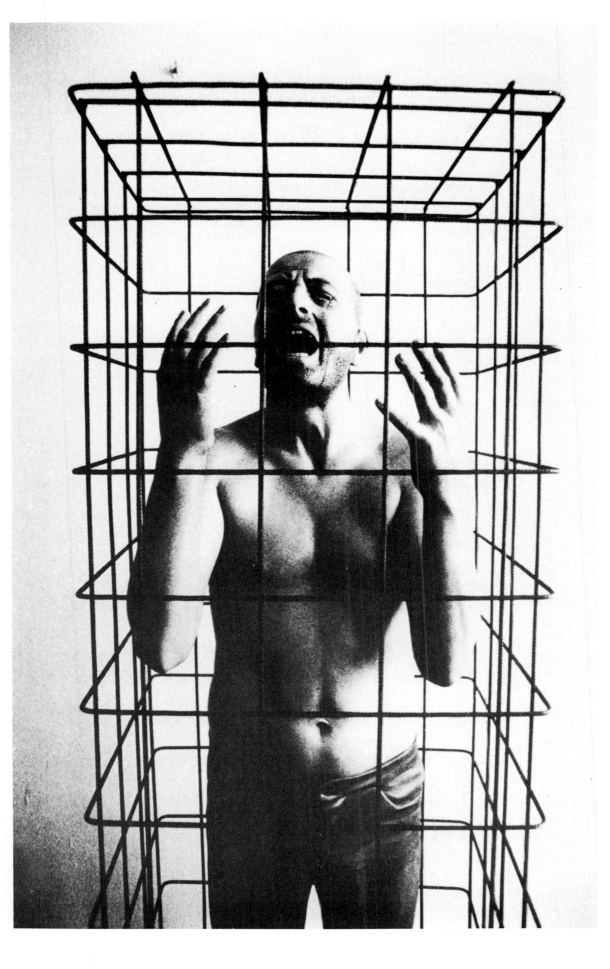

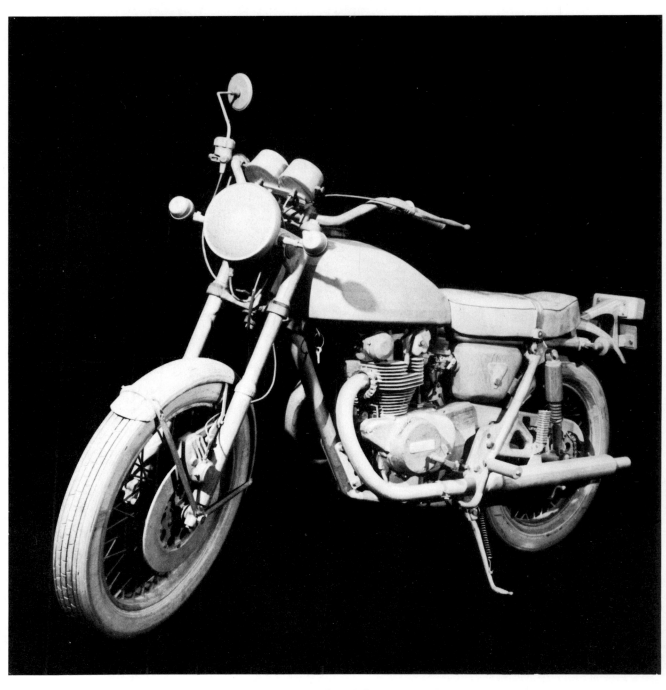

65. Fumio Yoshimura (b.1926): *Motorcycle*. 1973.
Wood, 101.6 × 218 cm. (40 × 86 in.) New York, Nancy Hoffman Gallery

the object reflected through the mirror of personal goods. Wear, use and their associations evoke a comparison.'

The contrast between Levine's work and that of Fumio Yoshimura is produced by an instructive difference of intention as well as by one of material and technique. One of Yoshimura's most startling creations is a minutely detailed wooden same-size facsimile of a motorcycle (Plate 65)—as undisguisedly made of wood as Francisco López's quinces are undisguisedly made of bronze. Yoshimura's aim is, if anything, anti-emotional. What fascinates him is the exercise of transferring as completely as possible what he has observed from one dimension of perception into another. 'I'm not representing the thing,' he remarks, 'I'm producing a ghost.'

78

One might anticipate a similar comment from the Frenchman Christian Renonciat. Working in carved wood, Renonciat makes a coat on a hanger (Plate 66), or a boot—things turned by sheer virtuosity in handling the material into apparitions of their former selves. But here, even more than with Yoshimura, it is pleasure in sheer skill that seems to be the motivating force. An identical virtuosity can be found in the famous Grinling Gibbons limewood carving of a lace jabot in the Victoria and Albert Museum (Plate 67). An encounter with this object produces a dizzy sensation of momentary disorientation, as if some mysterious exchange of substances was taking place all around one.

VI

Realist illusionism arouses a kind of disapproval which is excited by no other type of art. In the nineteenth century a contemporary commentator said of one of William Harnett's works: 'There is nothing whatever in the picture to please or instruct or elevate you. . . . The picture is unworthy because it is low and selfish.' Much the same things have been said about Super Realism. In the early 1970s, a critic reviewing 'Sharp Focus Realism' at the Sidney Janis Gallery in New York remarked more cautiously and also more percipiently: 'Always you must allow yourself to be seduced, if not ravished, by the illusion, and the sense of intellectual parity and conspiracy is destroyed by the rhetoric of effect.'

Because veristic art is associated with everything that originally resisted the modernist revolution, many recent critics have seen in Super Realism something which was not only bad in itself, but which entailed a deliberate betrayal of the modernist cause. There are two comments to be made, and in some ways they involve a paradox. Super

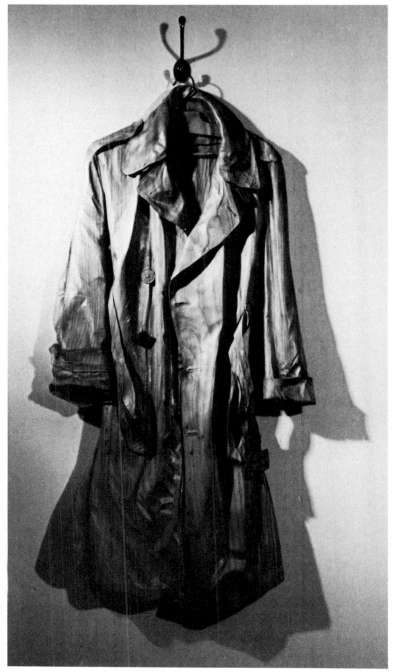

66. Christian Renonciat (b.1947): *Coat on Hanger.* Carved wood, lifesize. Paris, Galerie de Luxembourg

79

Realism, closely examined, is undoubtedly modernist, both in many of its attitudes, and in its chosen technical devices. Yet on the other hand it does seem to represent a revolt against modernist elitism, a desire for an art which everyone can understand.

One may argue from this that Super Realism is anti-academic rather than academic, and that it is now the Modern Movement which has, in its own turn, become an academy. Yet the style has characteristics which are far from reassuring—it is frequently pessimistic, or at least melancholy; it lacks affect and often seems to deny the free play of the emotions; it deliberately embraces the harshness and coldness of modern life, taking these qualities for its own. Even here, however, it is not consistent. One of the best pieces of evidence for its essential ambivalence is something said by the Californian painter Don Bechtle in an interview with the critic Brian O'Doherty: 'I can identify with my subject-matter in a sense—I like it and I hate it. There's a realisation that my roots are there.'

If Super Realist painting and sculpture need a justification other than the pleasure they are often capable of giving thanks to their own sheer professionalism, it is that they consistently reflect—and, despite the artists' protestations, frequently interpret—important aspects of our society which have never before found a place in art.

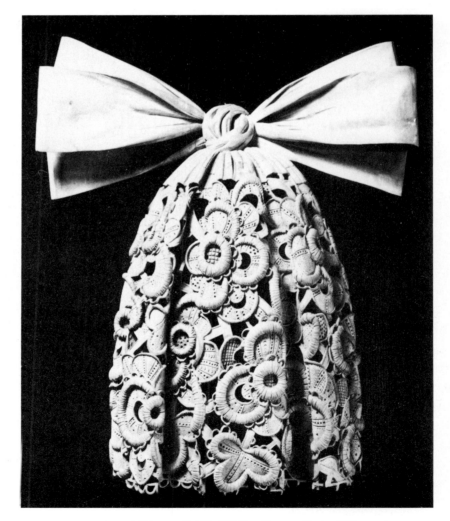

80

67. Grinling Gibbons (1648–1721): *Cravat*. Late 17th century. Limewood. London, Victoria and Albert Museum